Marvelous Mandalas Coloring Book

50 Fantastic mandalas

for coloring in.

By Artist
Dwyanna Stoltzfus

Copyright © 2017 by Dwyanna Stoltzfus

ALL RIGHTS RESERVED

ISBN-10:1981437401

ISBN-13:978-1981437405

This publication is for personal use only.
No part of this publication may be reproduced, stored in a retrieval
System, or transmitted in any form or by any means – electronic, mechanical, photocopy,
Or any other - without the written permission
of the artist/publisher – Dwyanna Stoltzfus.

Unauthorized reproduction of any part of this publication by any means
Is an infringement of copyright.
All artwork and images in this publication are
Protected by copyright laws.

Join the Fun!!

Share your colored pages!!

You are invited to color the pages
From this and all publications by
Dwyanna Stoltzfus. Then scan and post
Your colored creations in
Coloring with Dwyanna
Adult Coloring Group
On facebook
https://web.facebook.com/groups/1519357628356169/?_rdr
Join Coloring with Dwyanna Coloring Group,
And have fun sharing your colored pages
And meeting new coloring friends.
Members of the group will also have access
To free coloring pages.
You are welcome to share your colored pages on
Any social network, make sure to mention the title of
The book and the author/artist name.
Uncolored images may not be shared.

Check out my blog at:

coloringwithdwyanna.blogspot.com

PDF Printable coloring pages available

On Etsy at

https://www.etsy.com/people/dwyannastoltzfus

Follow Dwyanna's art on facebook at

Oodles of Doodles Designs –

Adult Coloring Books by

Dwyanna Stoltzfus

https://web.facebook.com/Oodles-of-Doodles-Designs-Adult-Coloring-Books-by-Dwyanna-Stoltzfus-743502922387046/

About:

Get ready to color 50 fantastic mandalas by Artist Dwyanna Stoltzfus.

In this adult coloring book you will find 50 fantastic illustrations, printed one per page.

A collection of wonderful images. In this book you will find a variety of mandalas.

Some with lots of detail and some with less detail.

There are some beautiful heart mandalas. A few whole page mandalas.

And a few gorgeous whole page zendalas.

You can use this coloring book to help you relax and unwind after a long day.

Or you can use it just for fun. You can color the designs simply or add depth

and creativity by shading and highlighting. Crayons are not recommended for the intricate

detail in this book but can be used on a few of the designs. You can color with fine tip markers,

gel pens, and colored pencils. Ultra fine tip markers and fine liners

work great on the designs that have intricate detail.

Enjoy the experience of coloring!!

But most of all relax and have fun!!

Coloring tips:

If you desire to add depth to your coloring you can shade with colored pencils.

Use dark colors around edges and into the peaks. Blend in light colors for the

middle and more open spaces. You can use black to darken areas,

and white to lighten and brighten areas.

Acknowledgments

Thank You to my family for all your support
of my art and this project.
I could not have done it without you!!

Thank You God for the gift and love
Of art and drawing!!

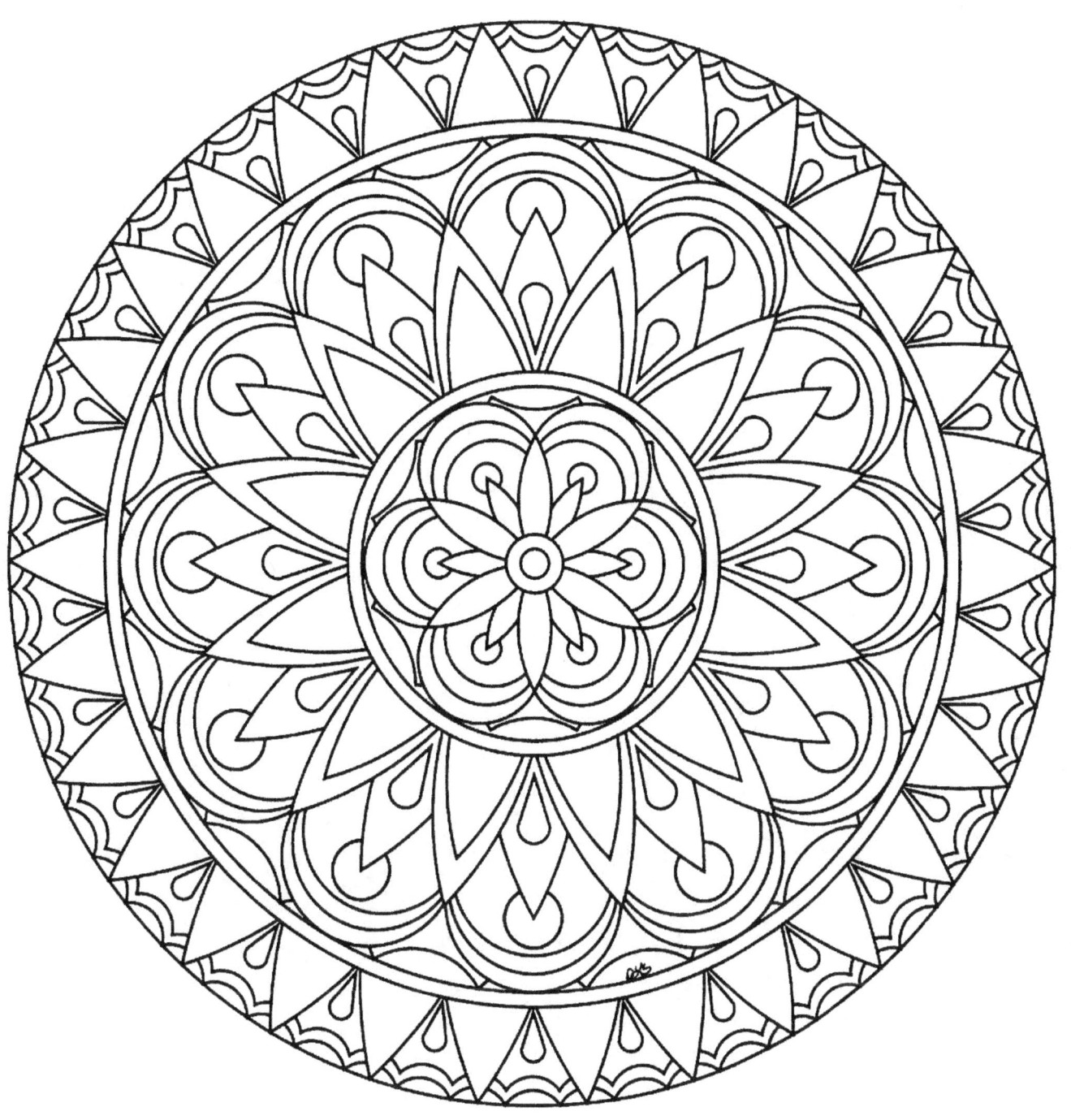

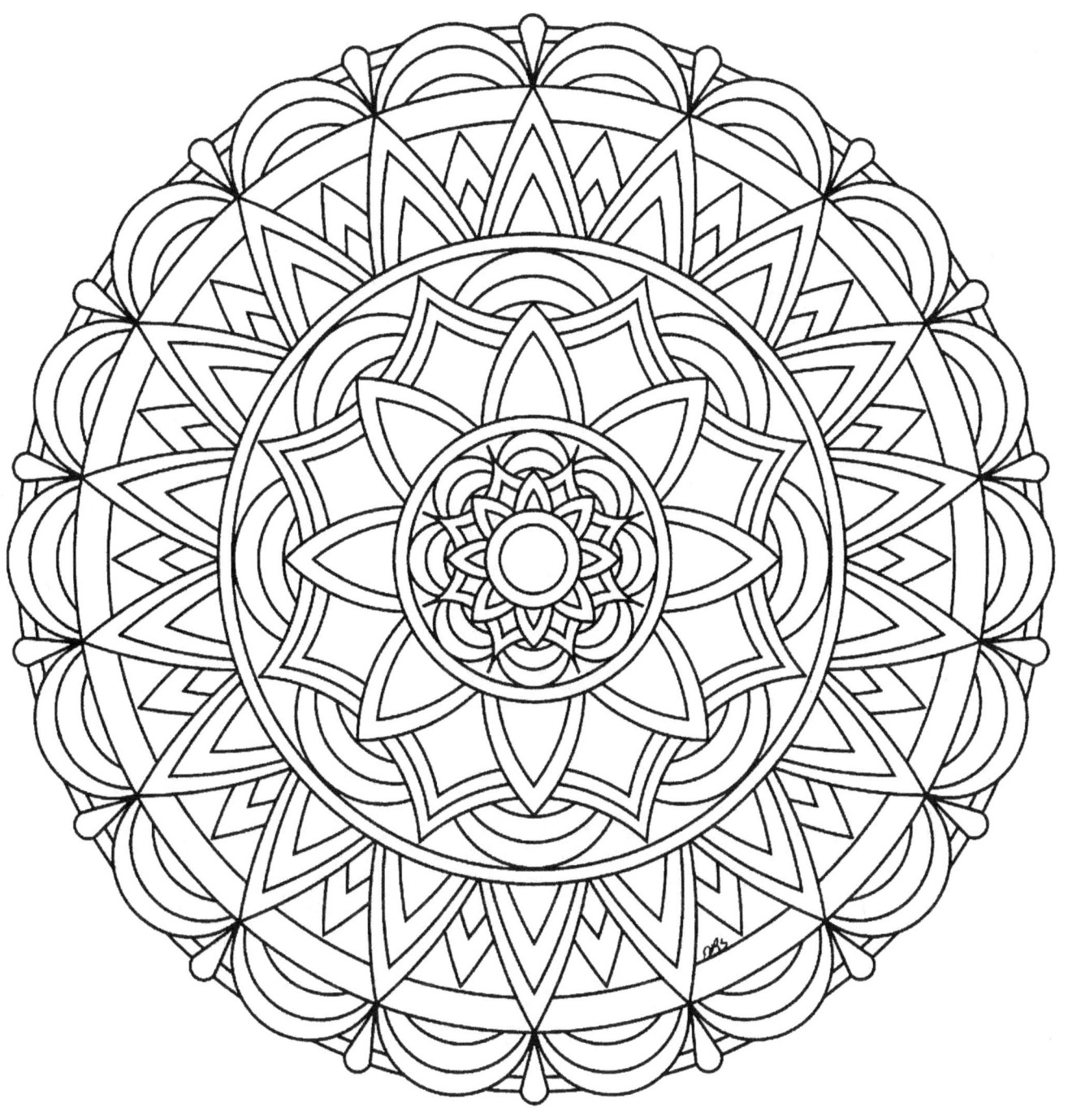

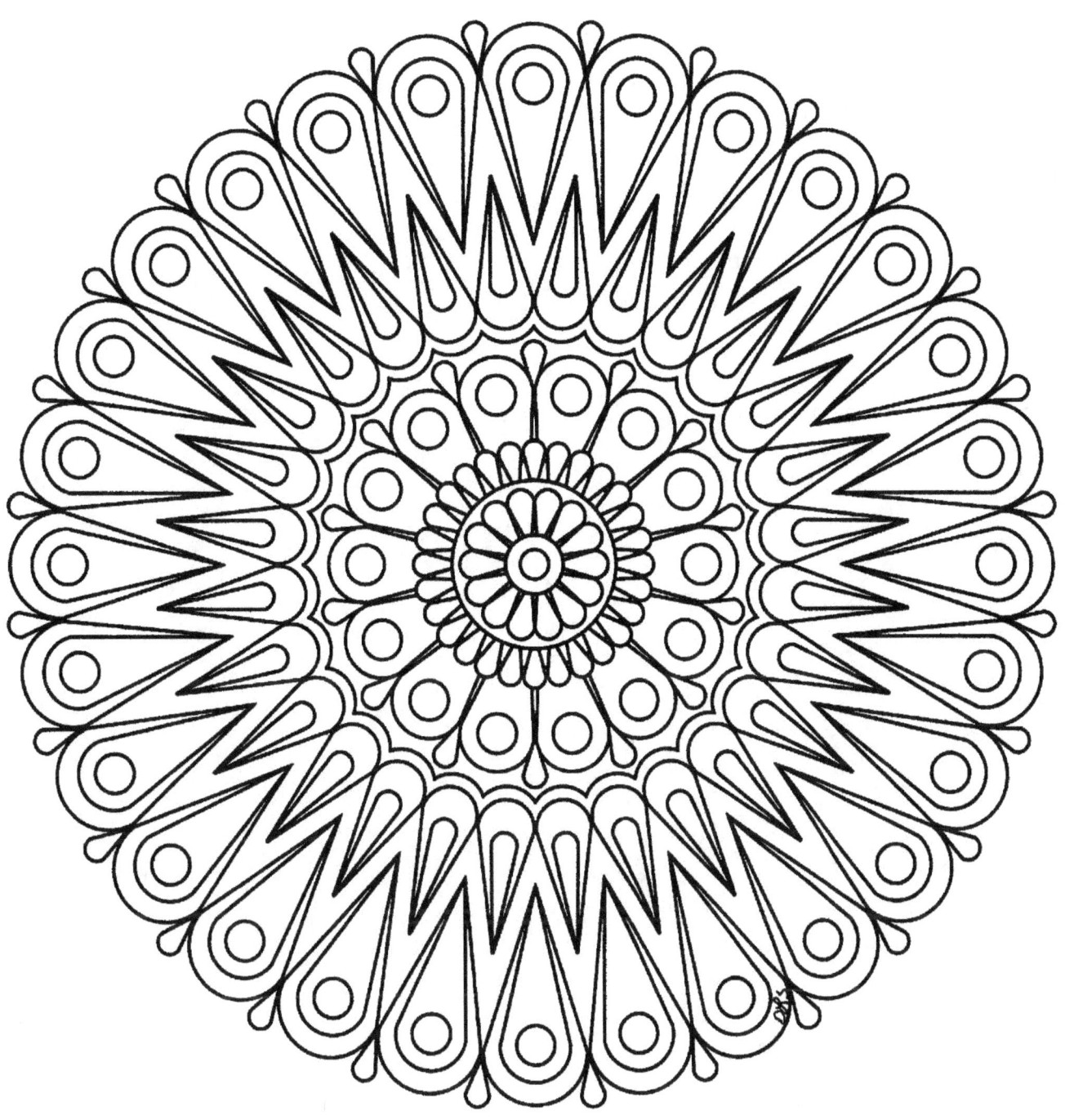

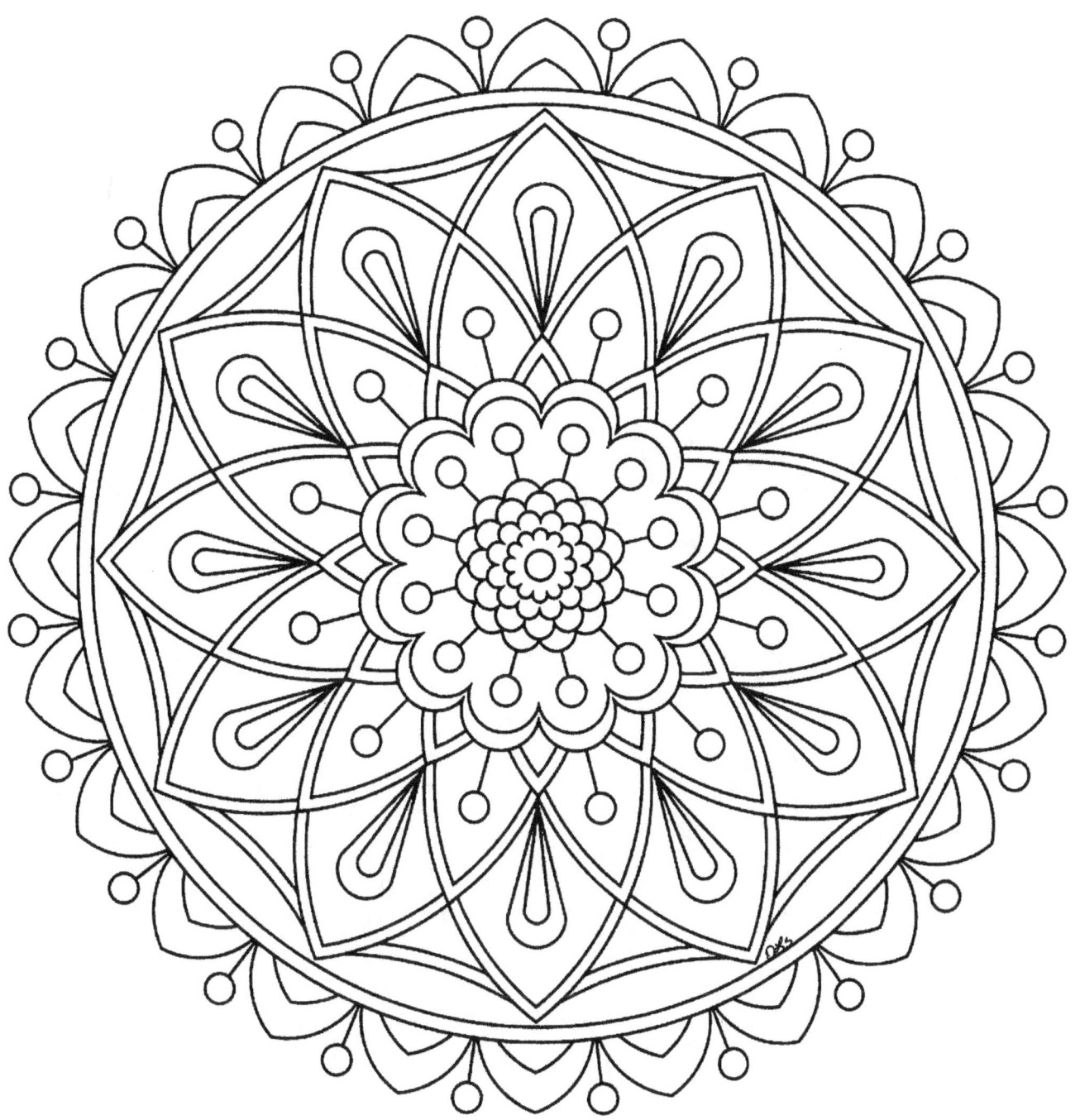

© Copyright 2017 Dwyanna Stoltzfus

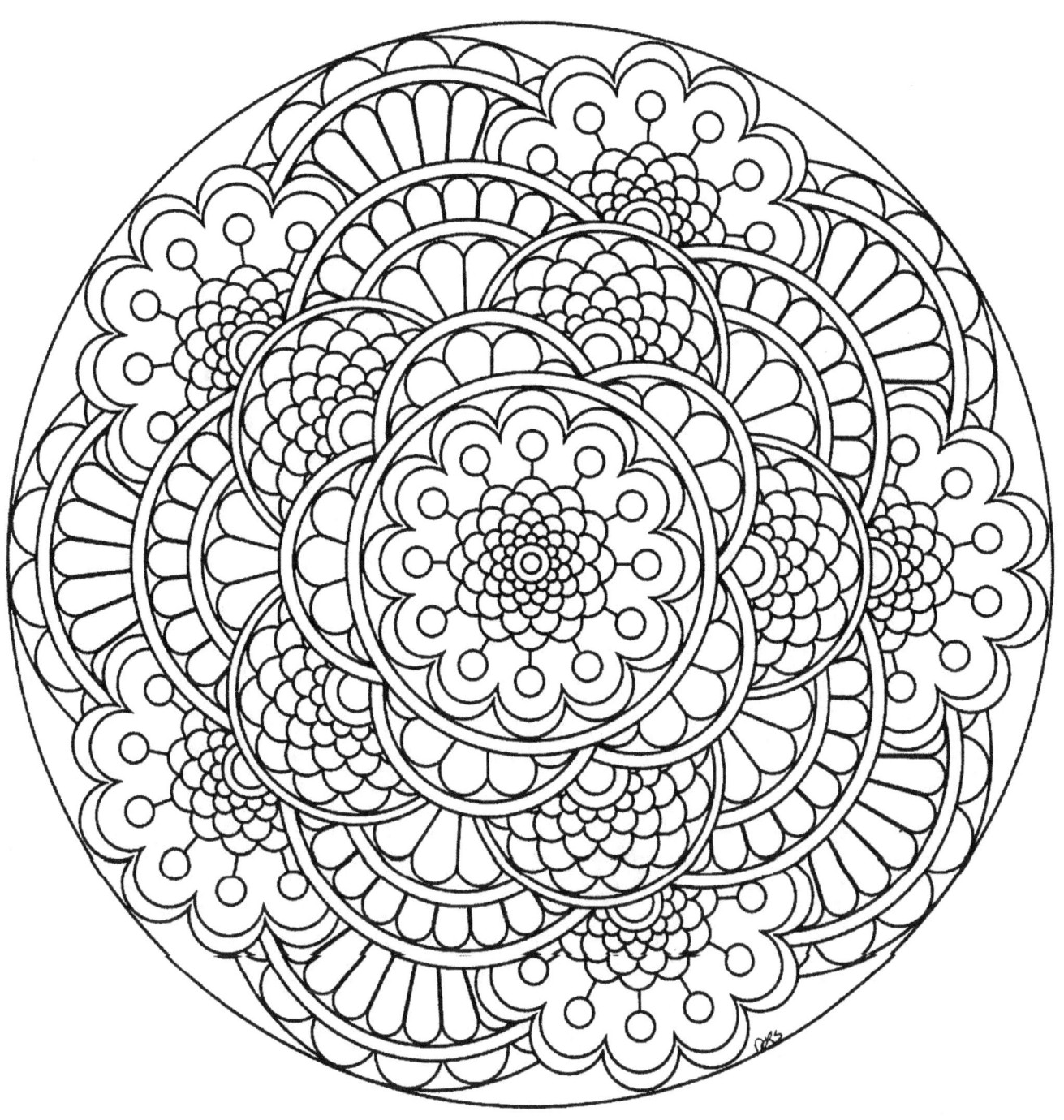

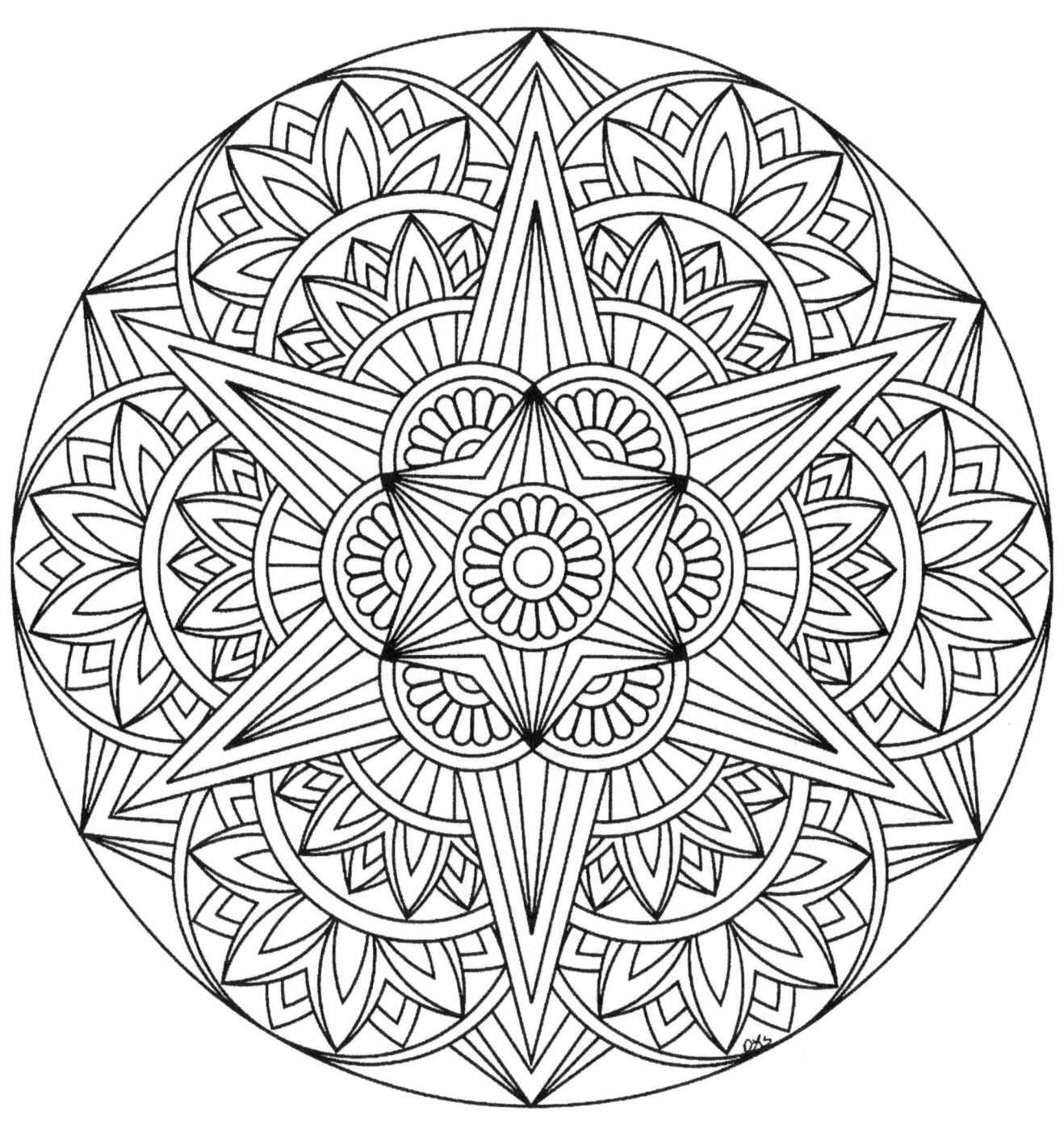

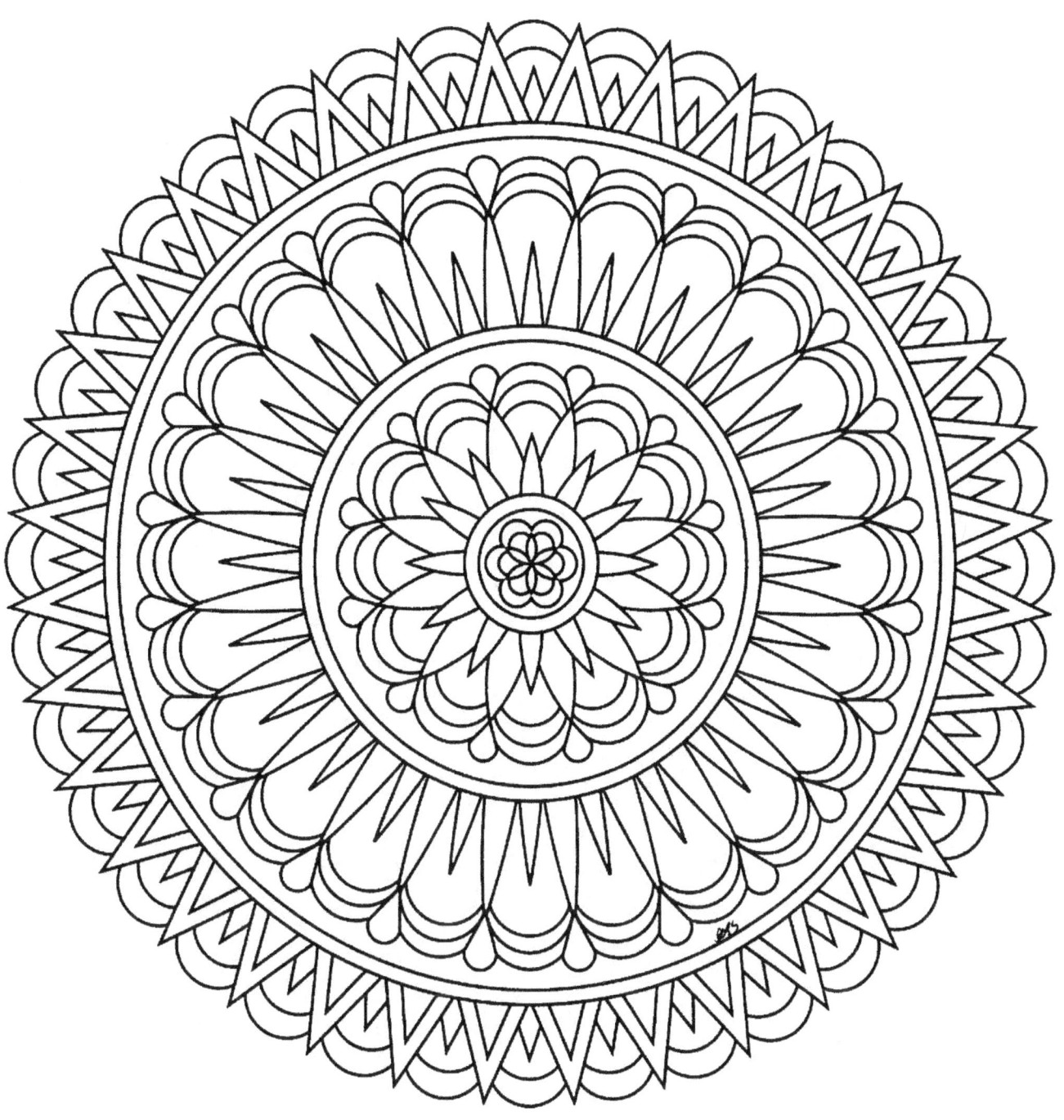

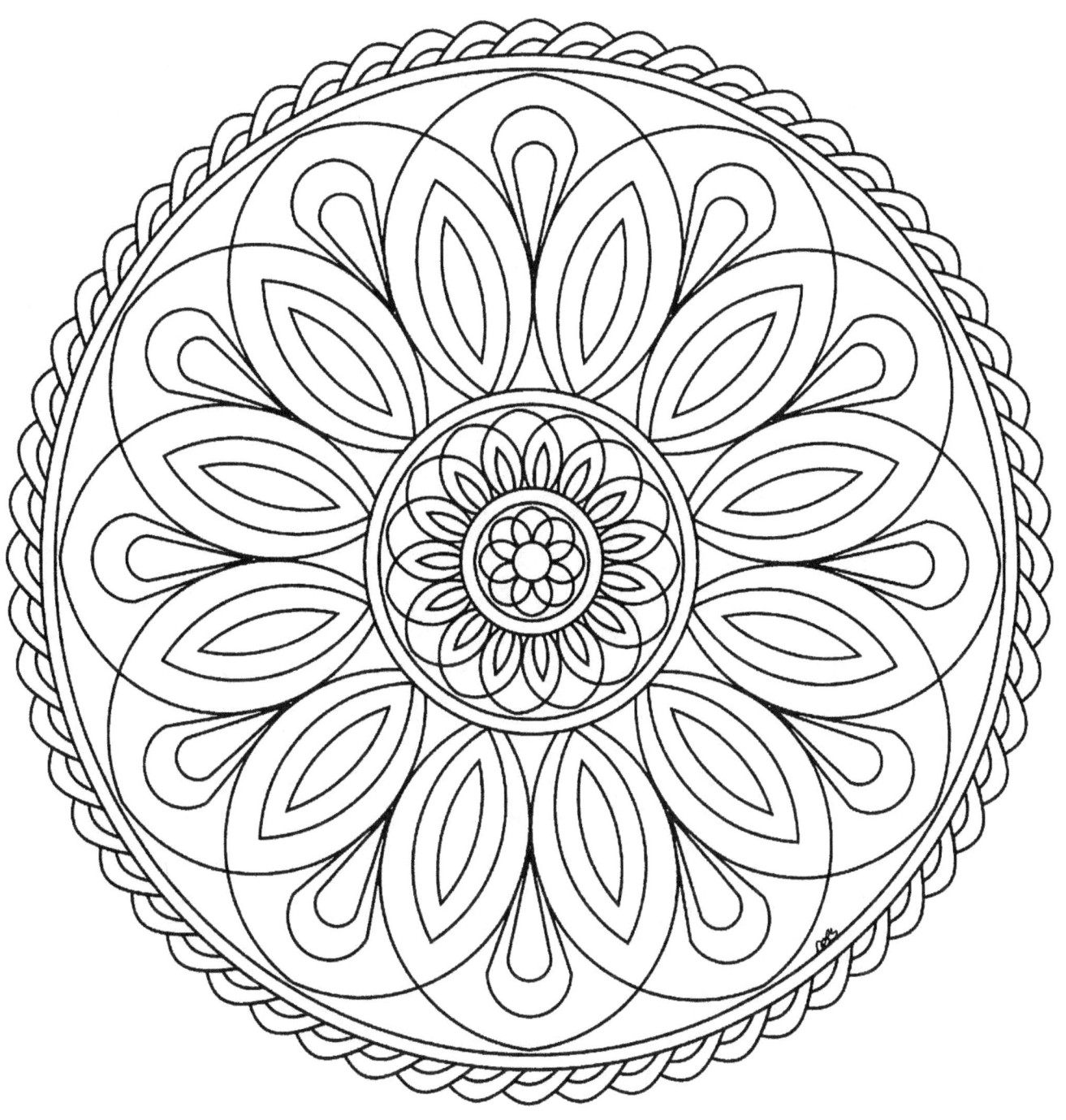

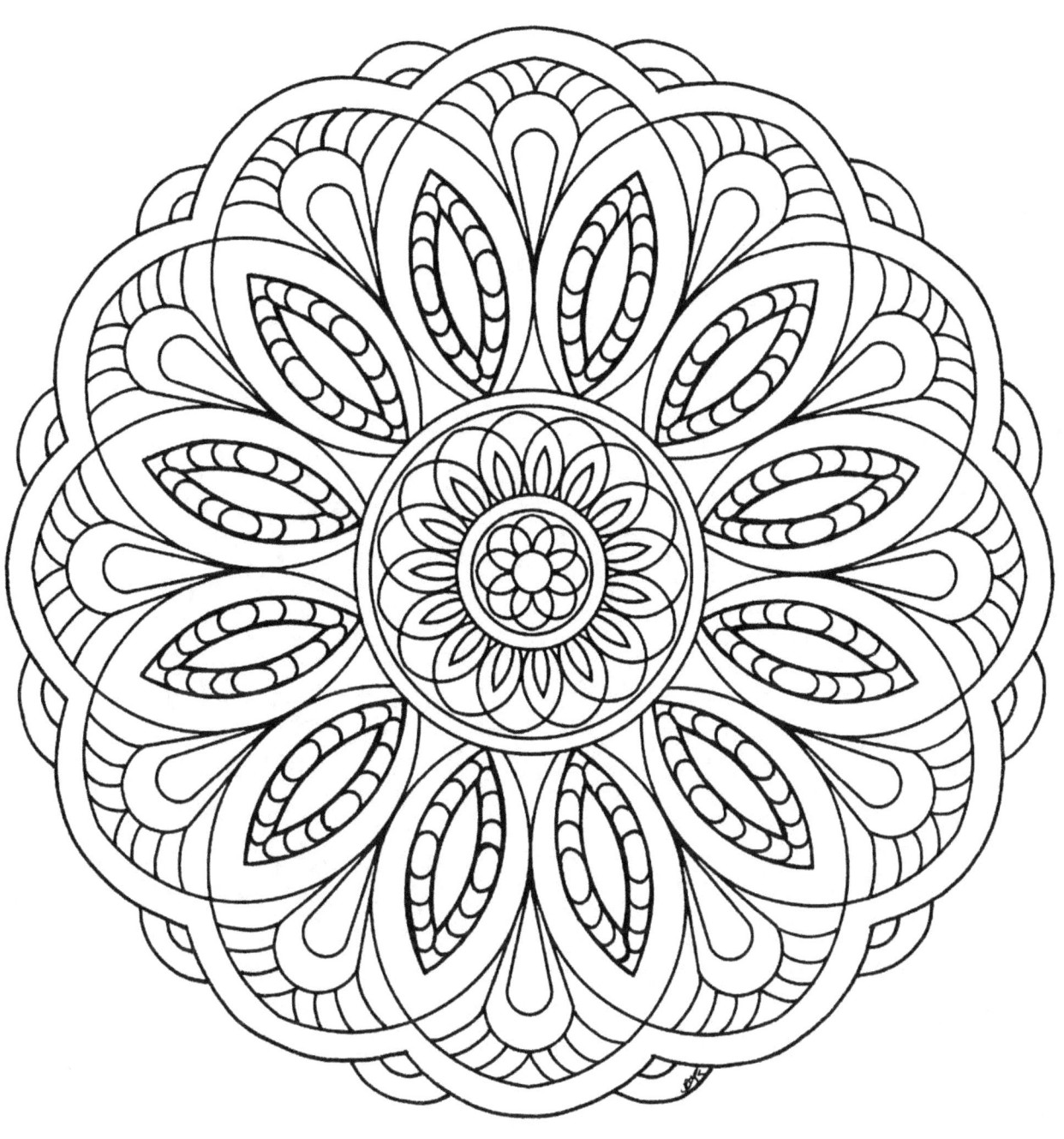

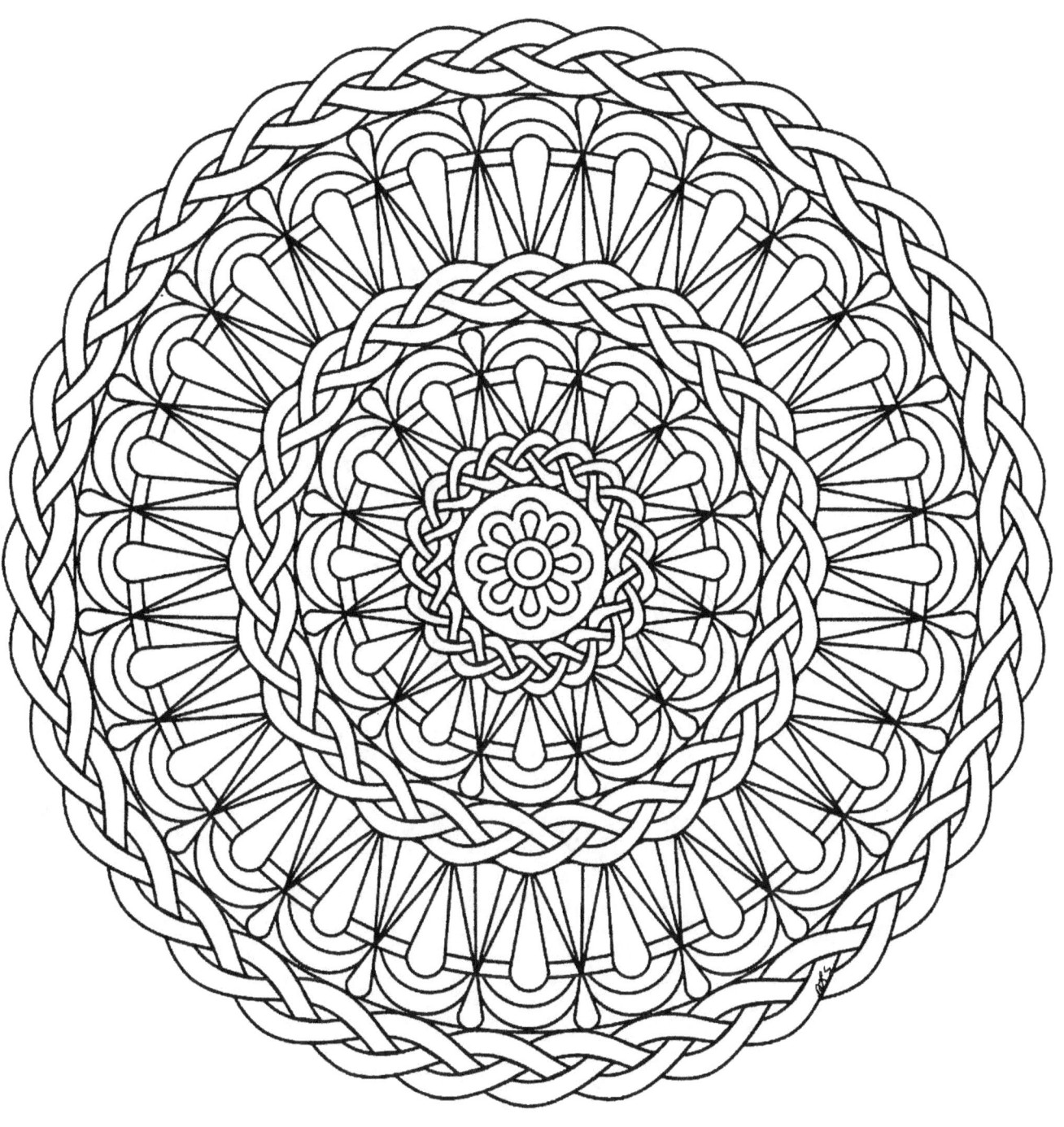

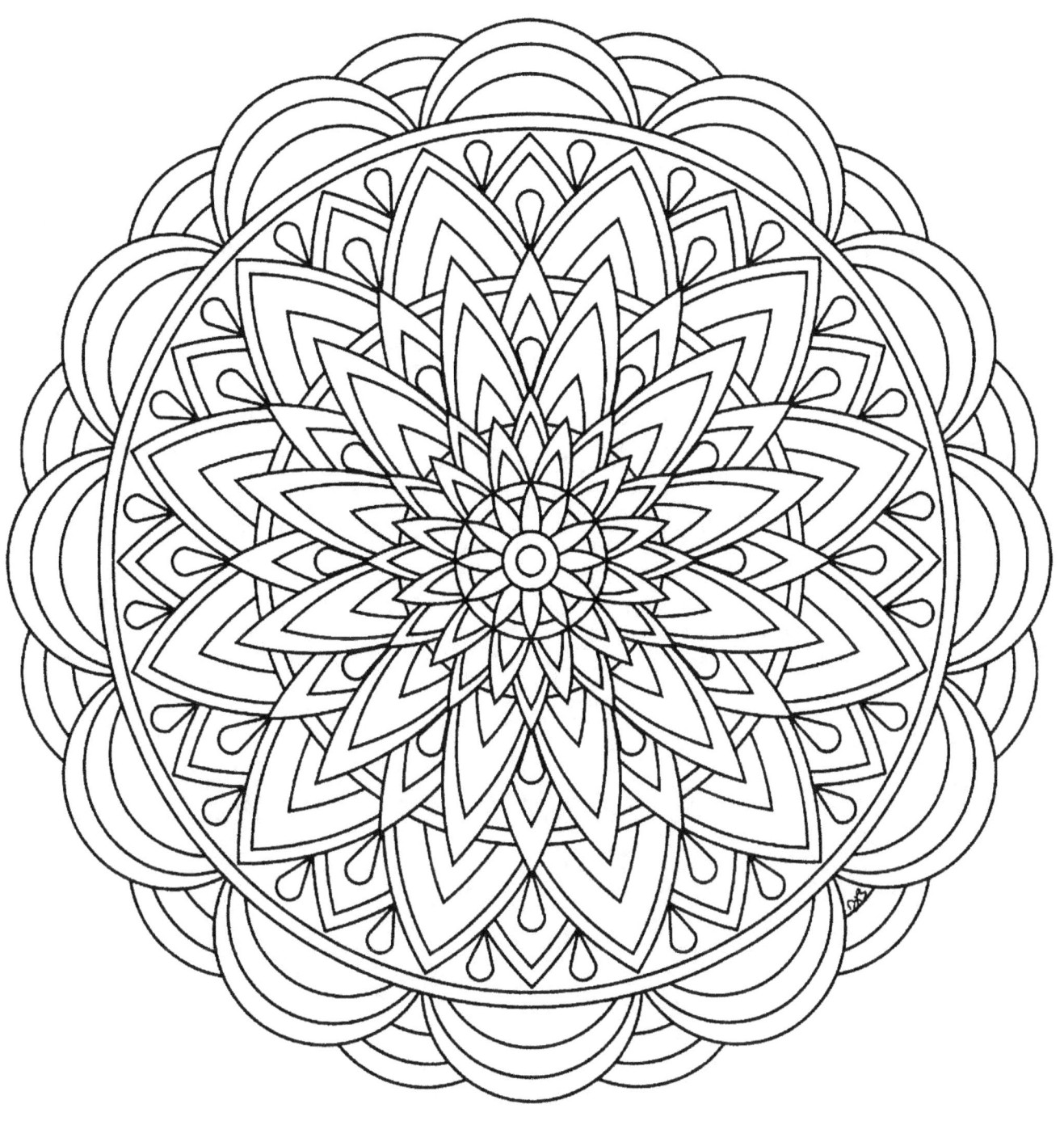

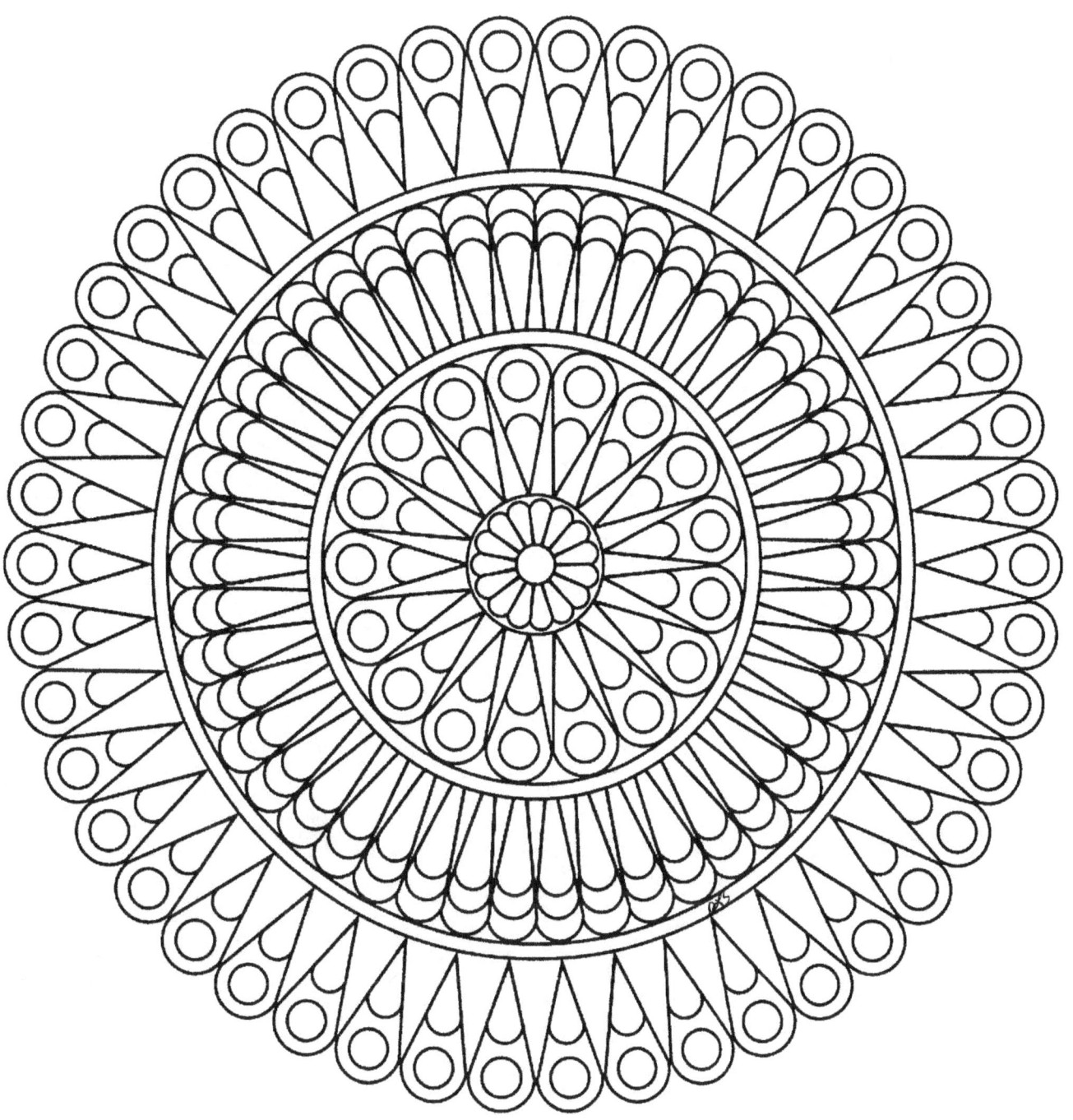

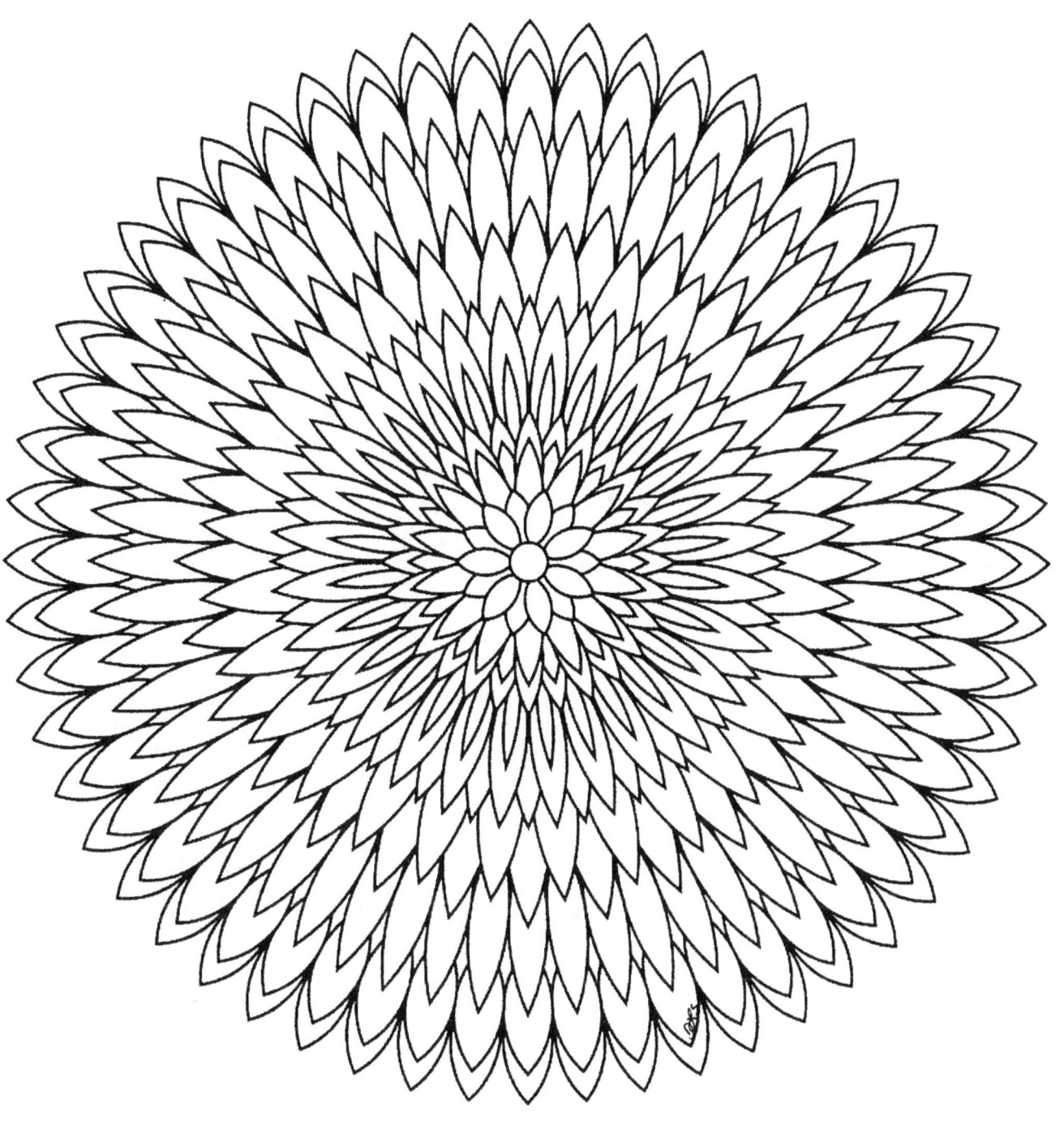

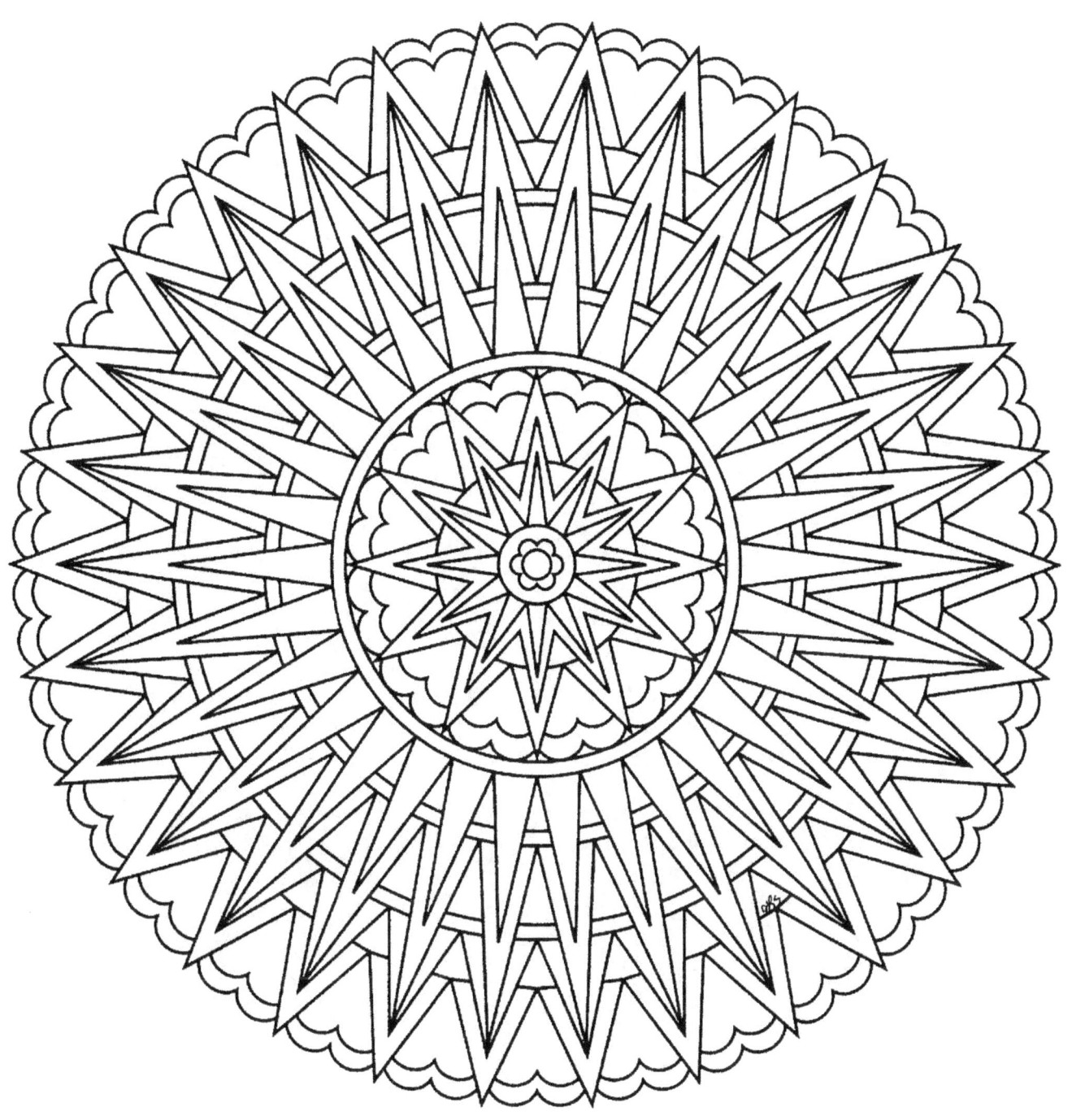

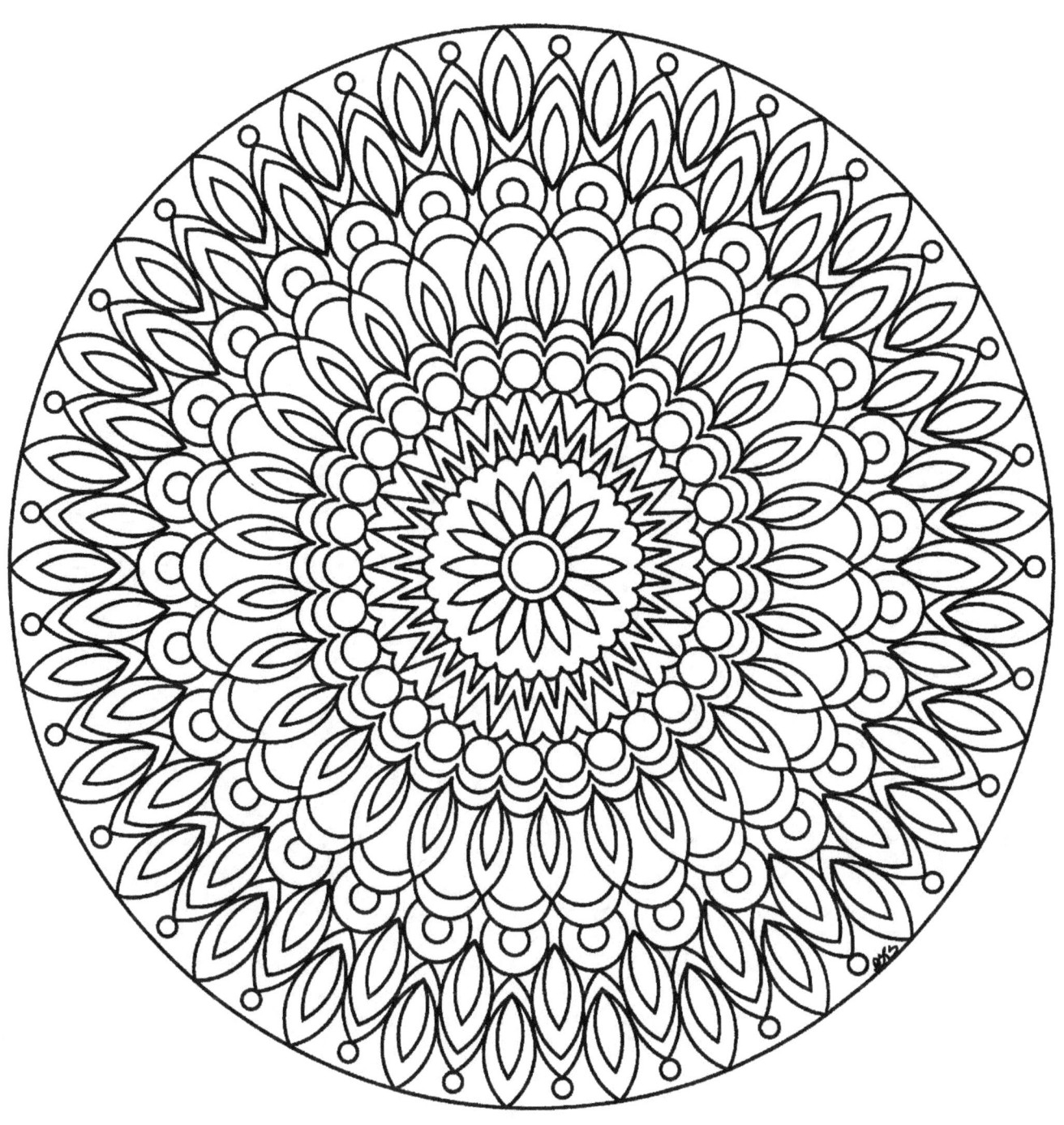

© Copyright 2017 Dwyanna Stoltzfus

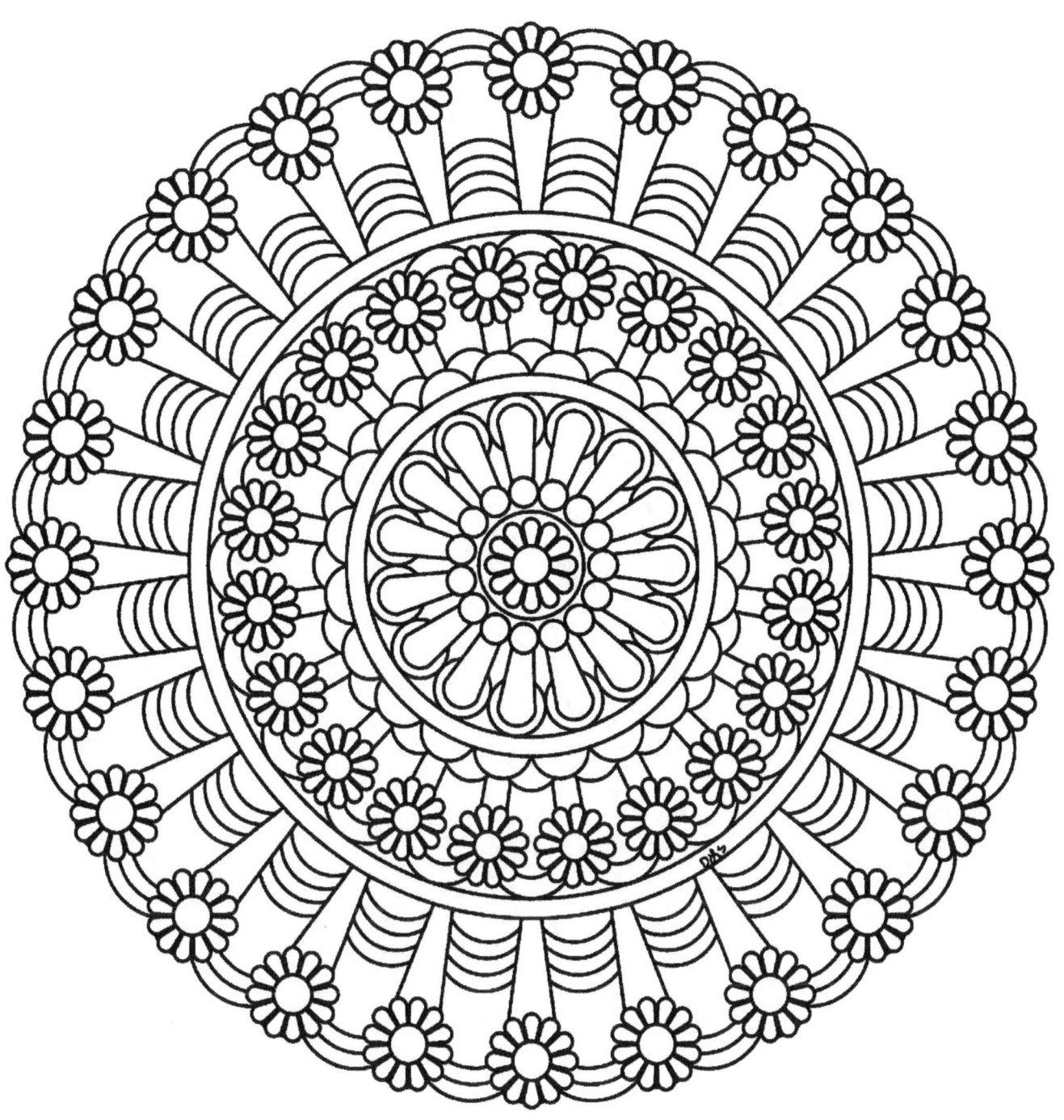

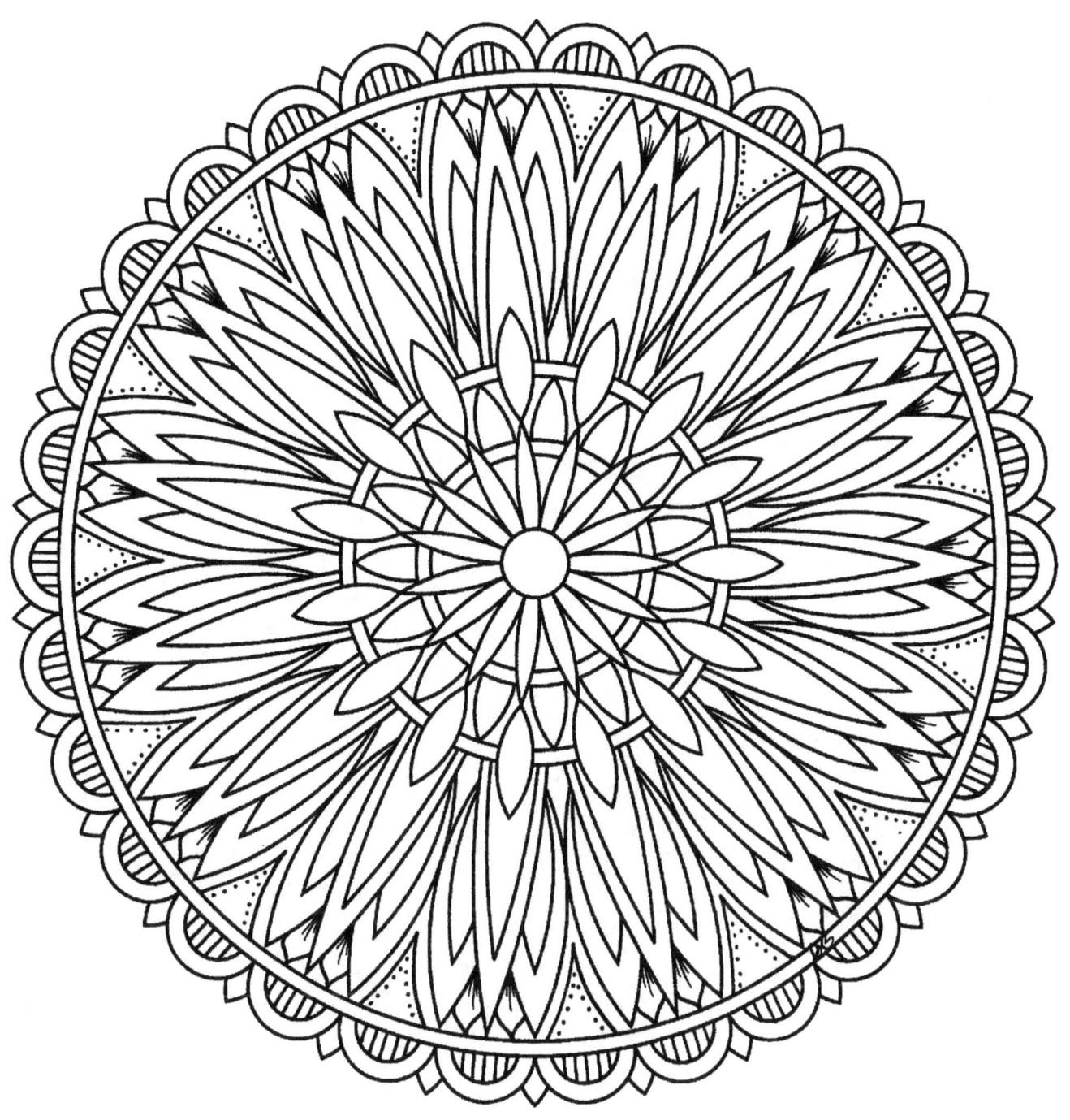

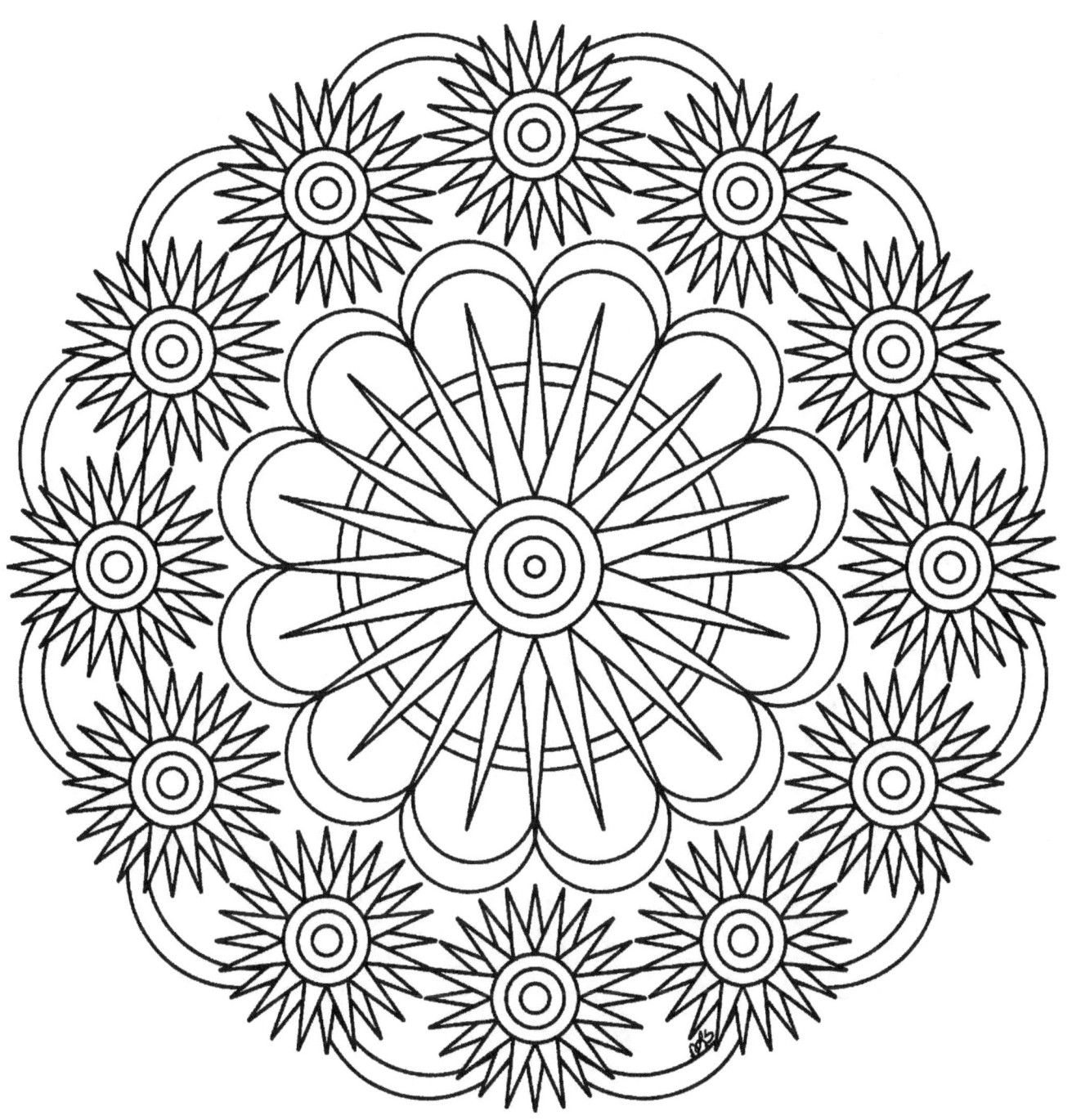

© Copyright 2017 Dwyanna Stoltzfus

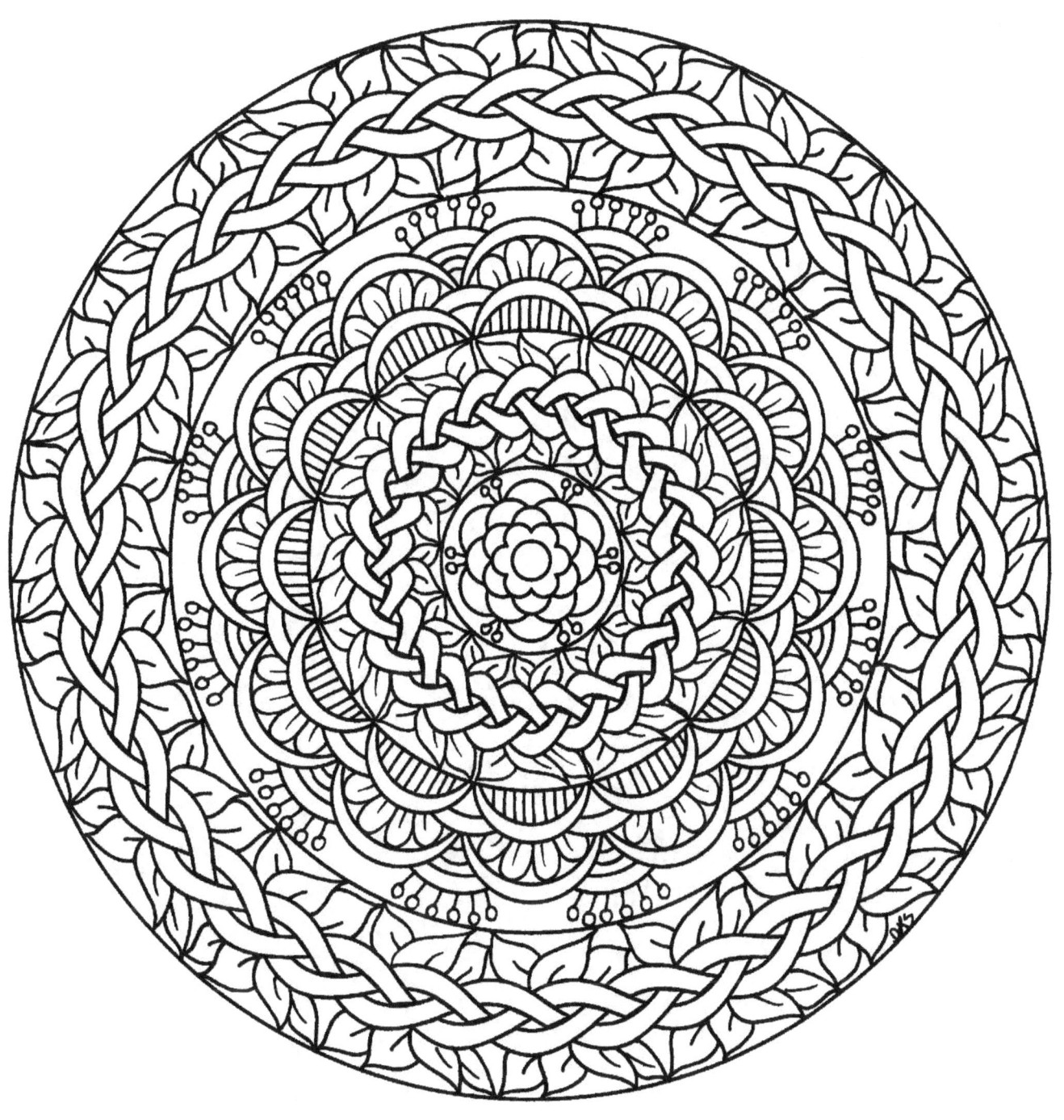

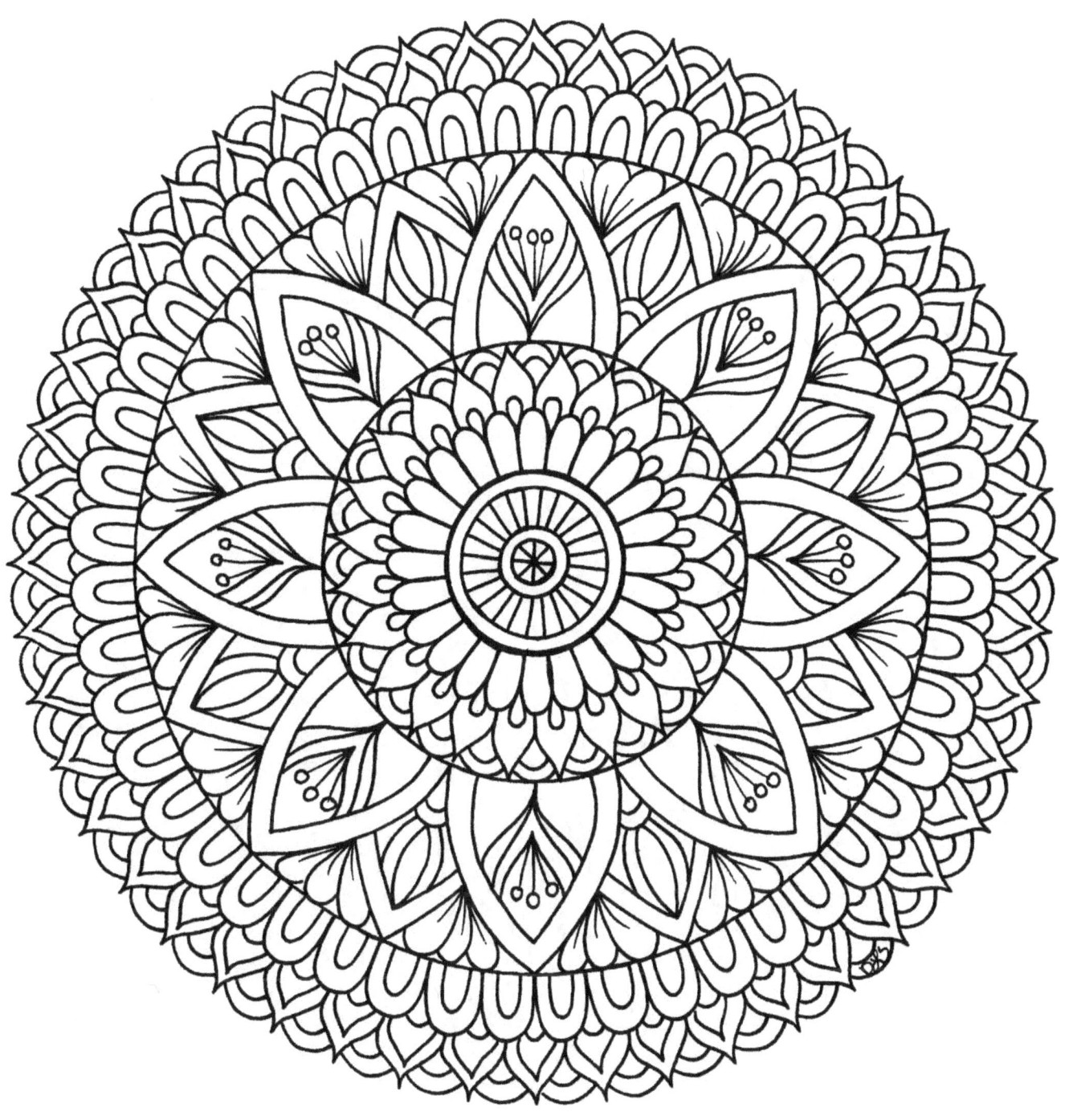

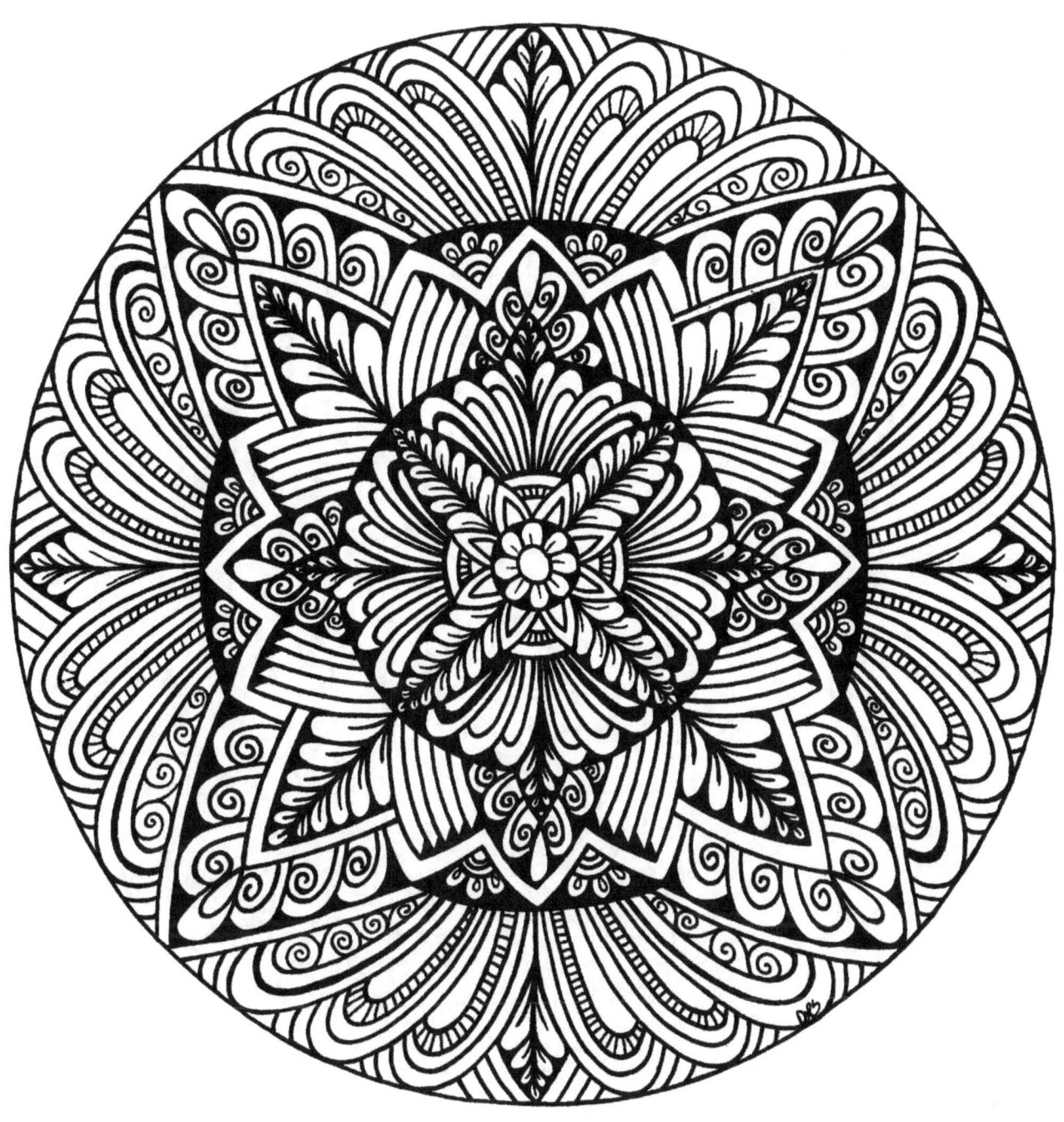

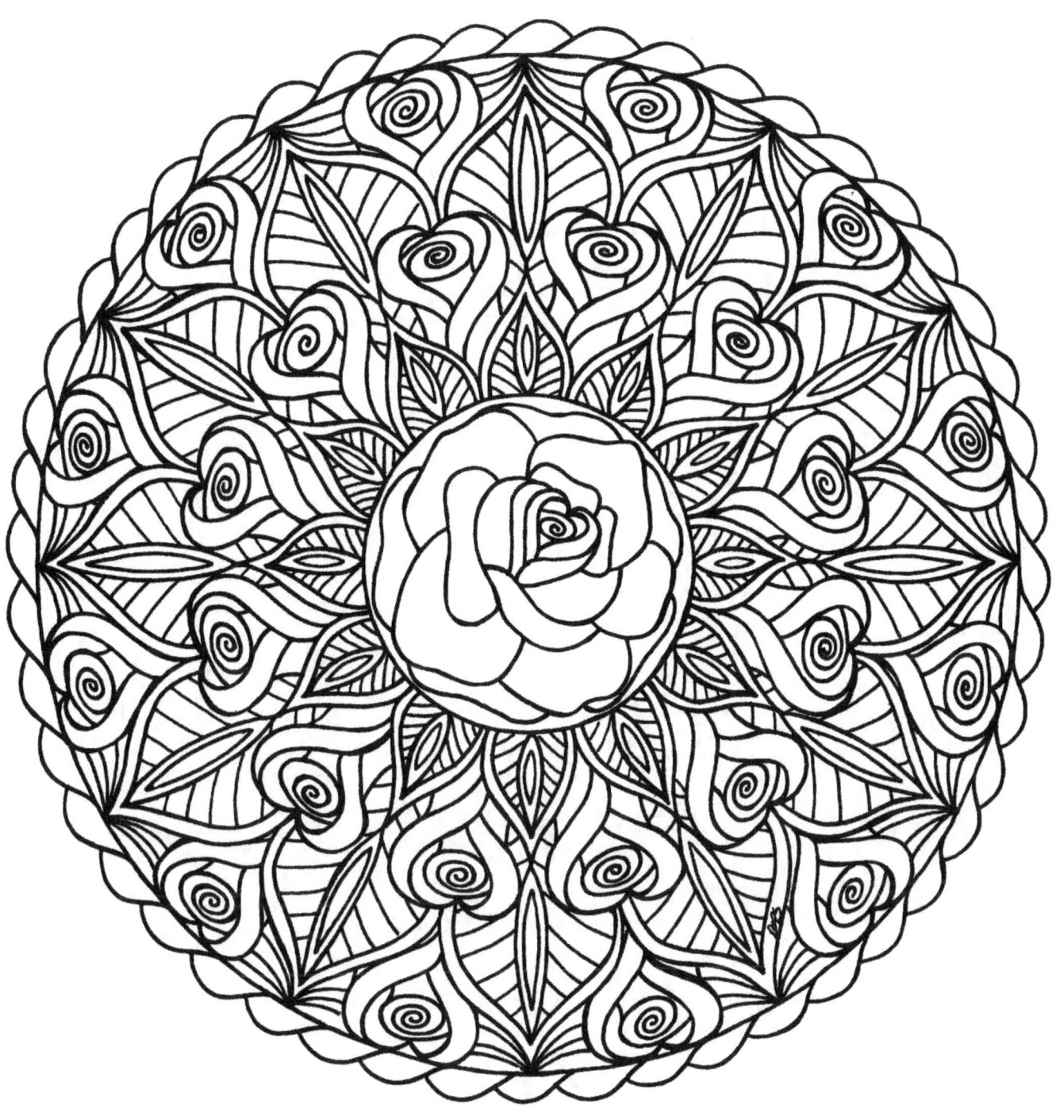

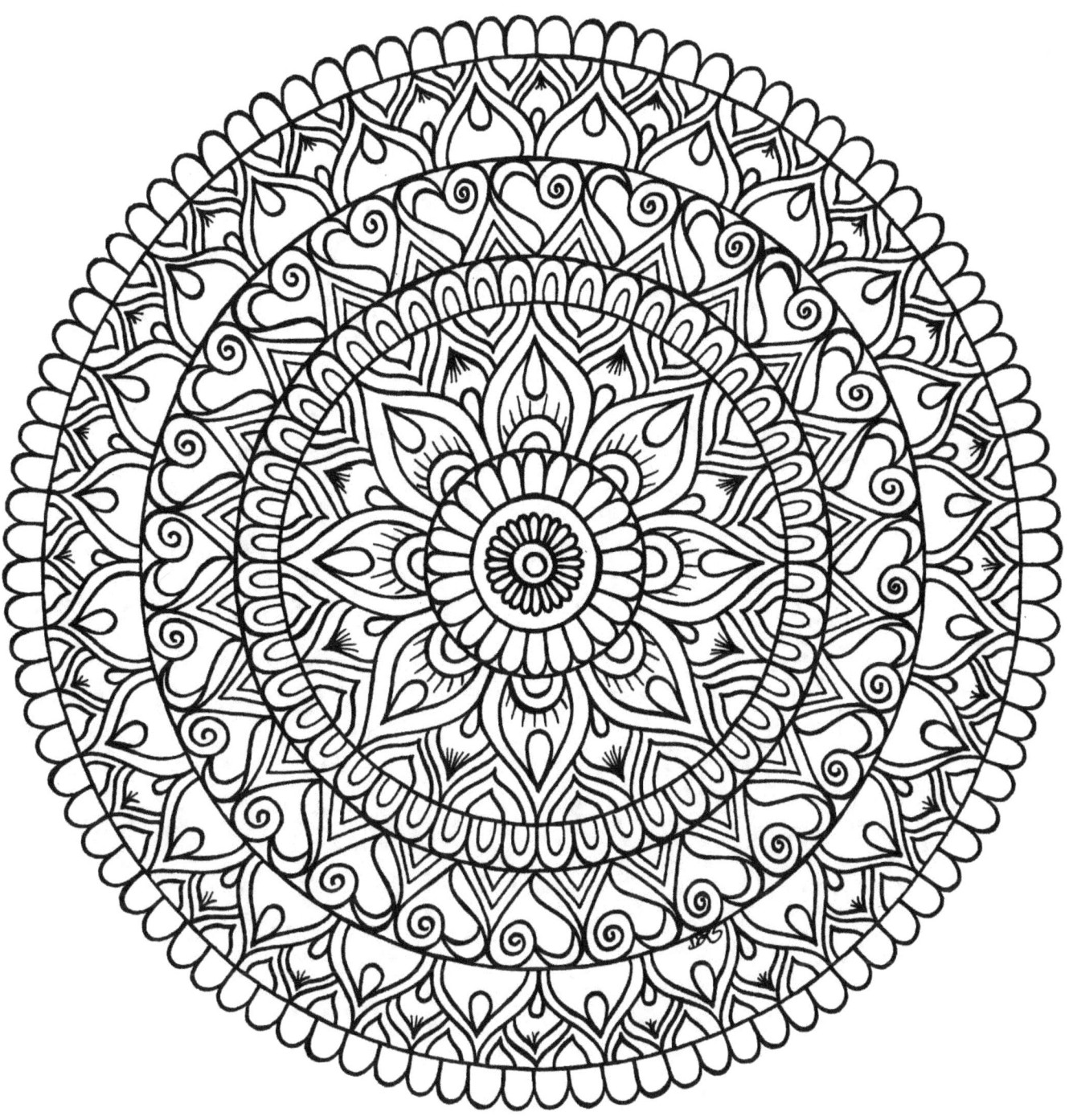

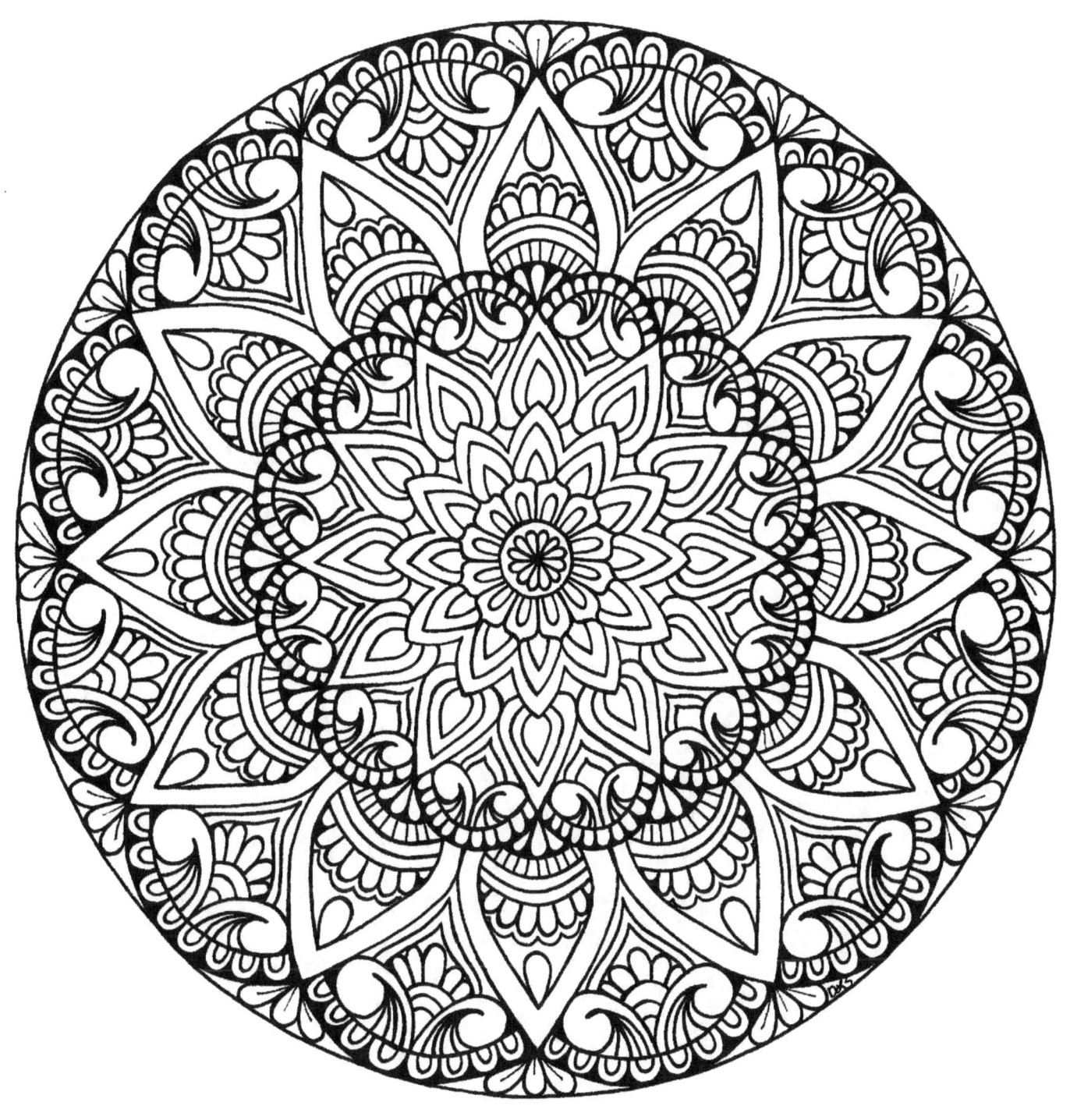

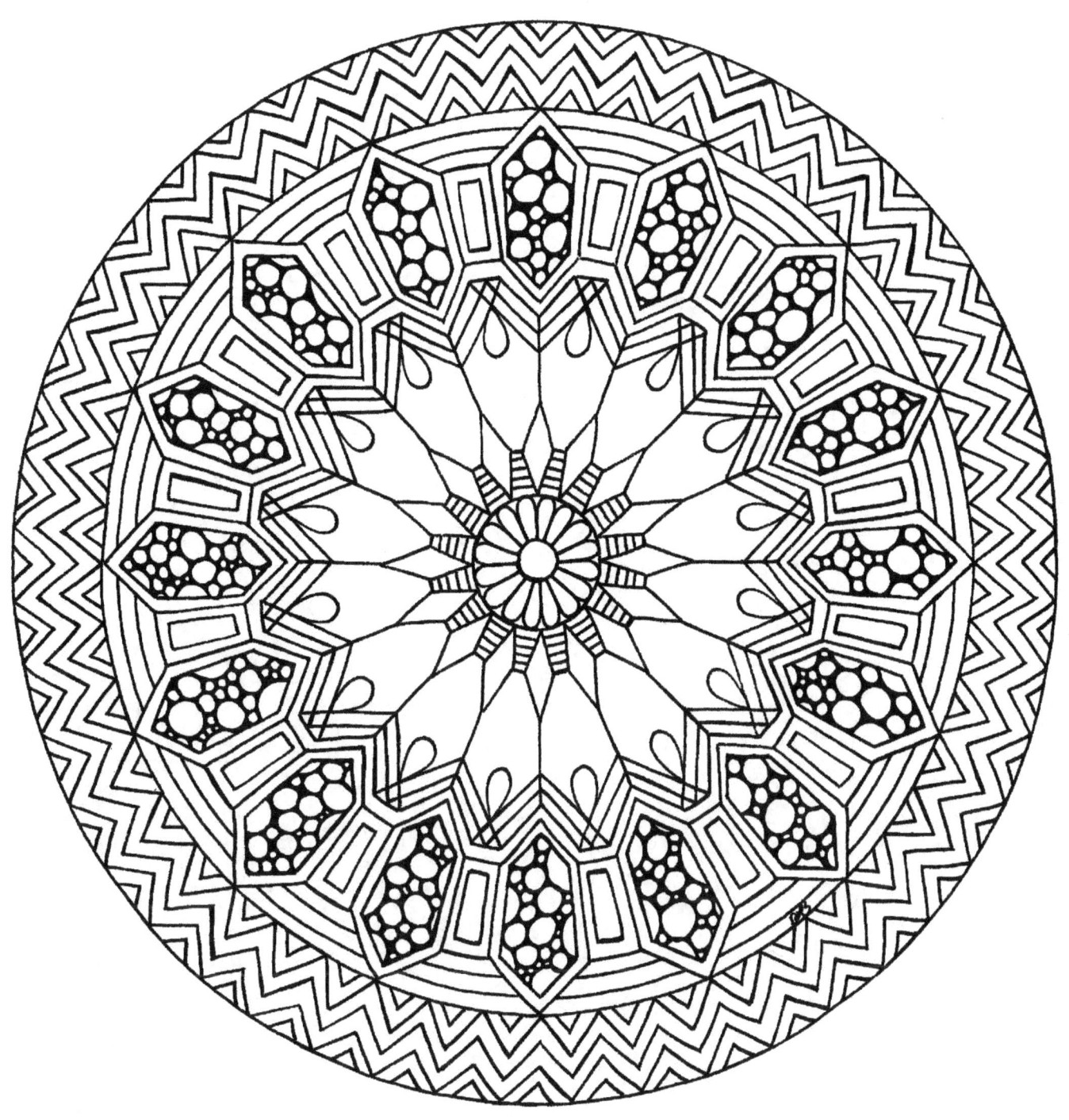

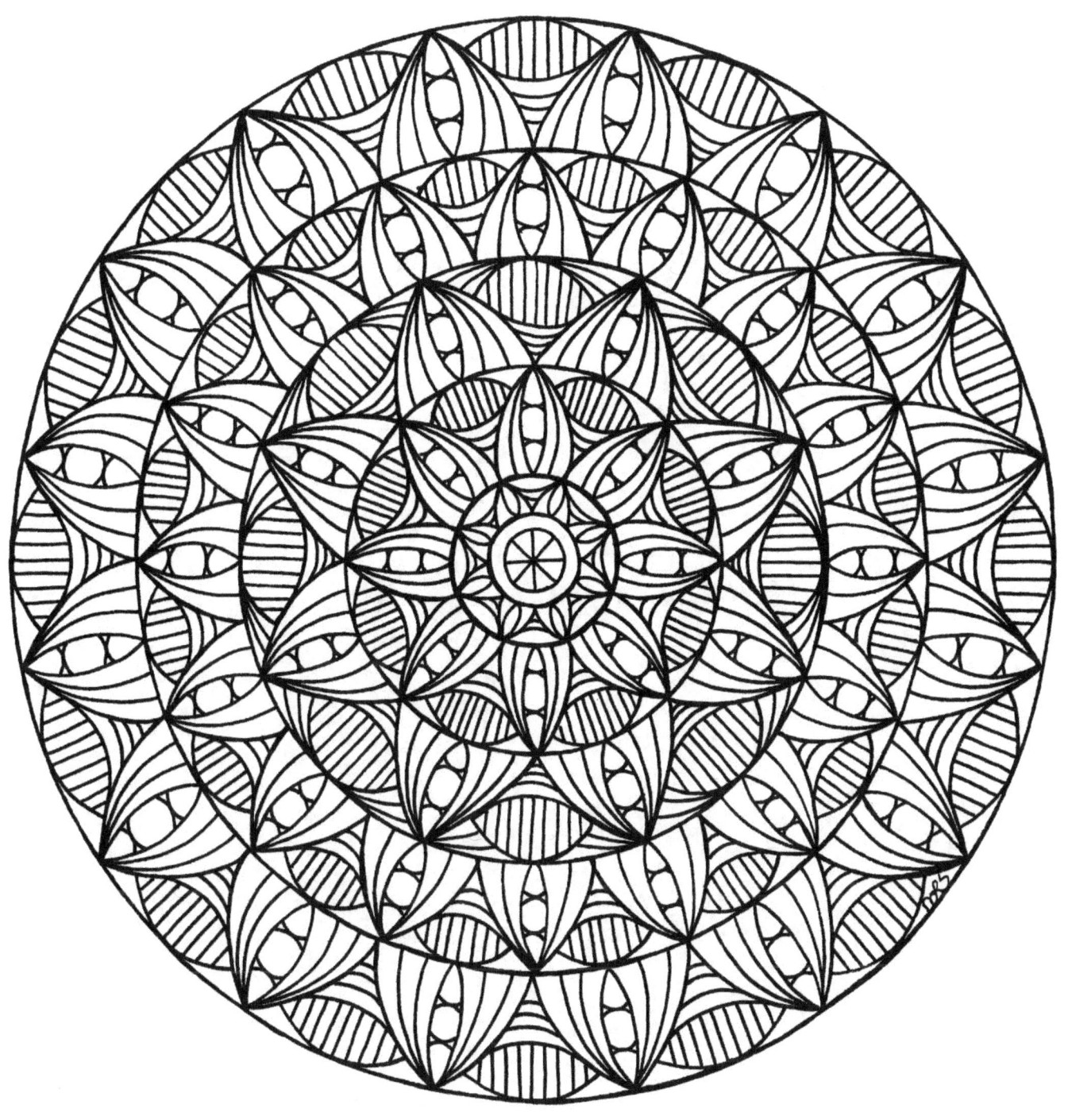

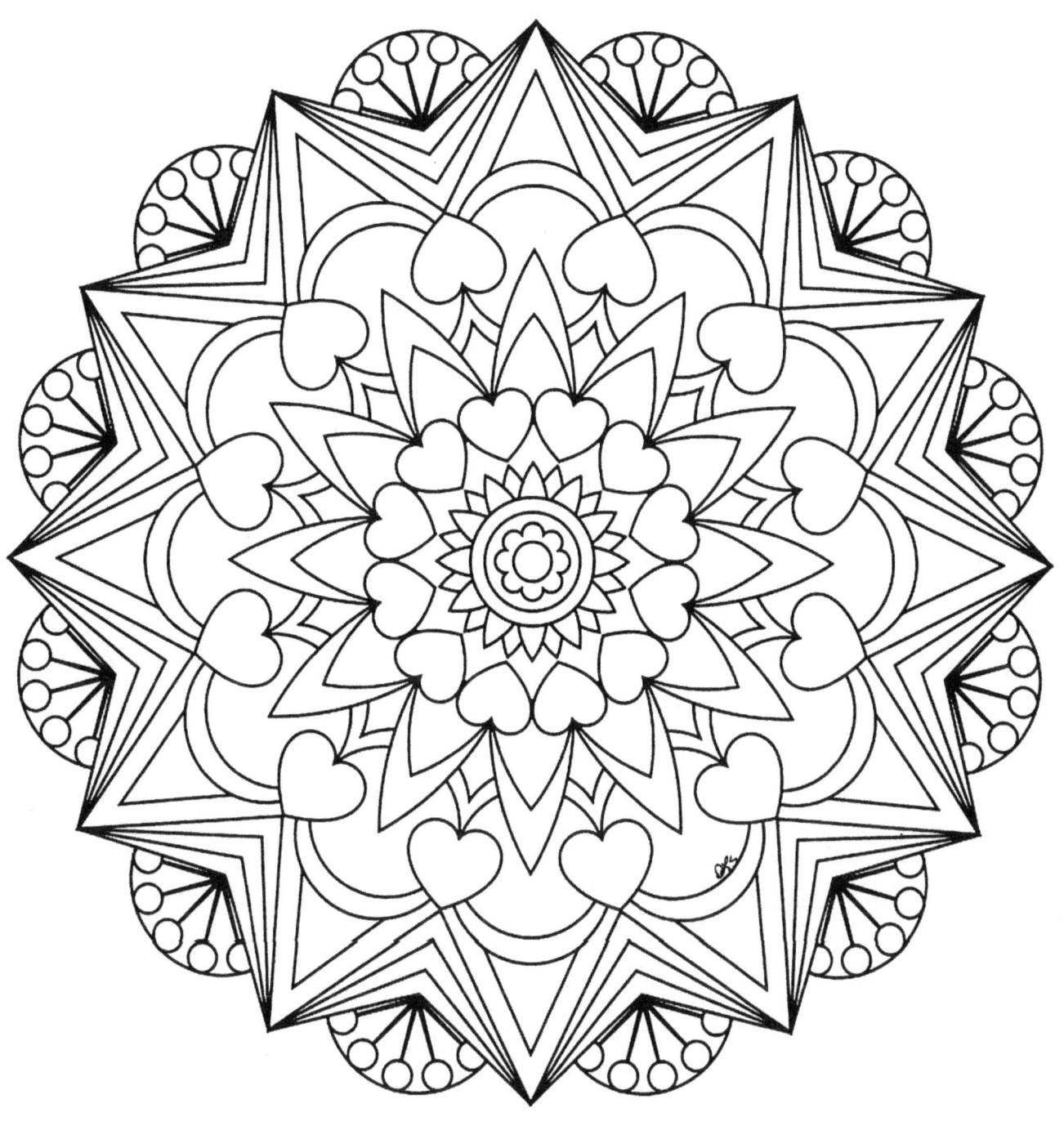

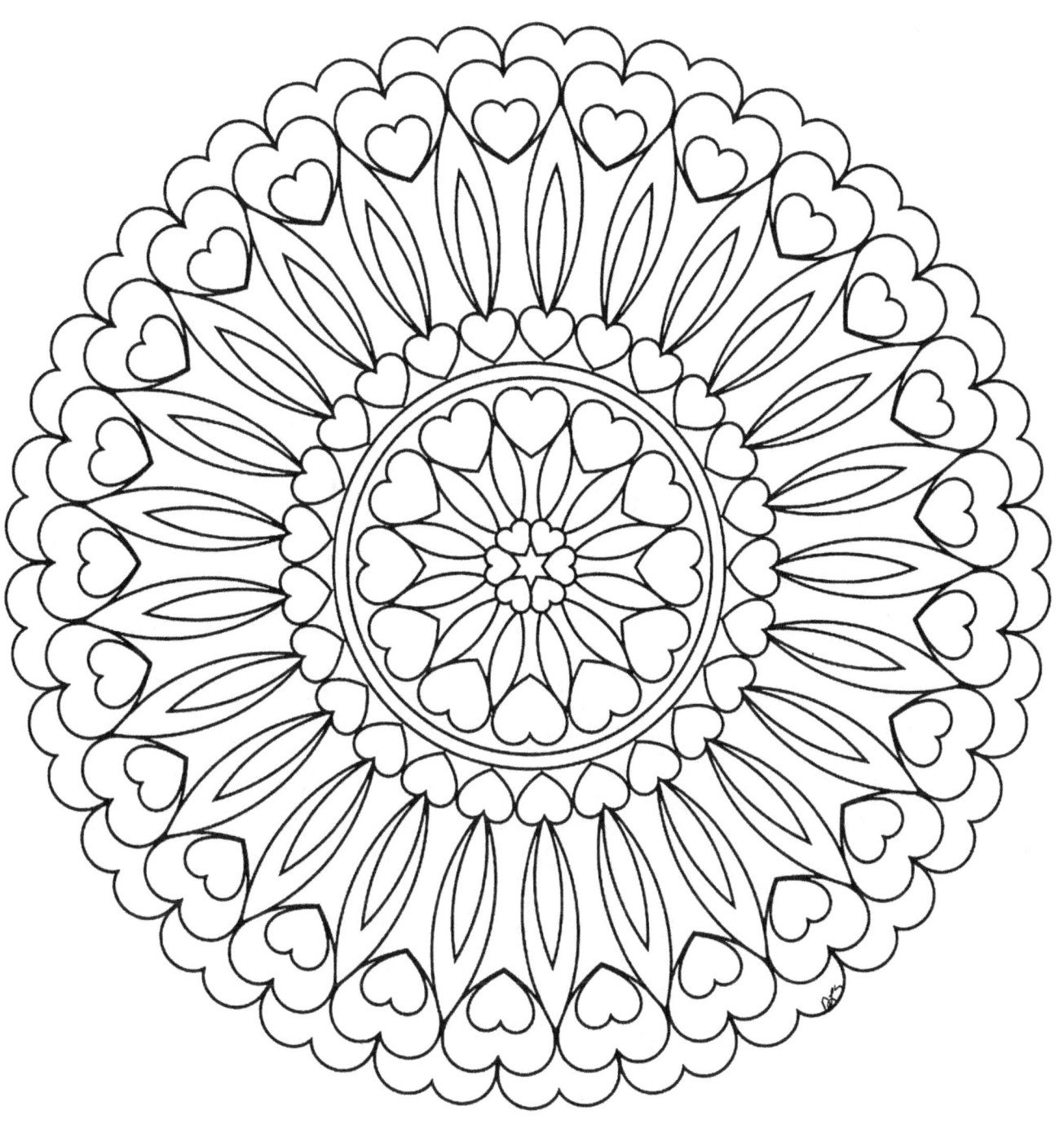

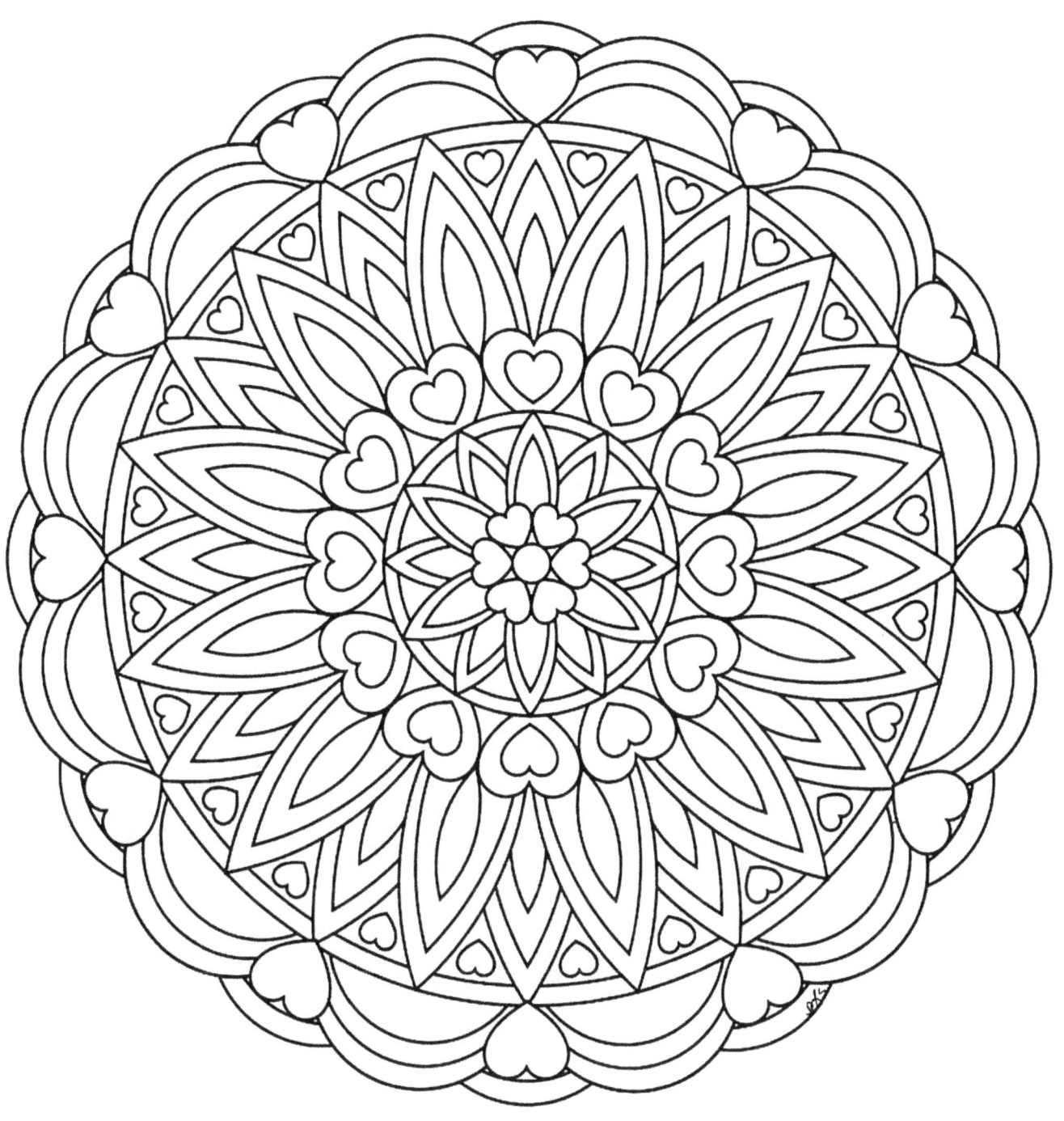

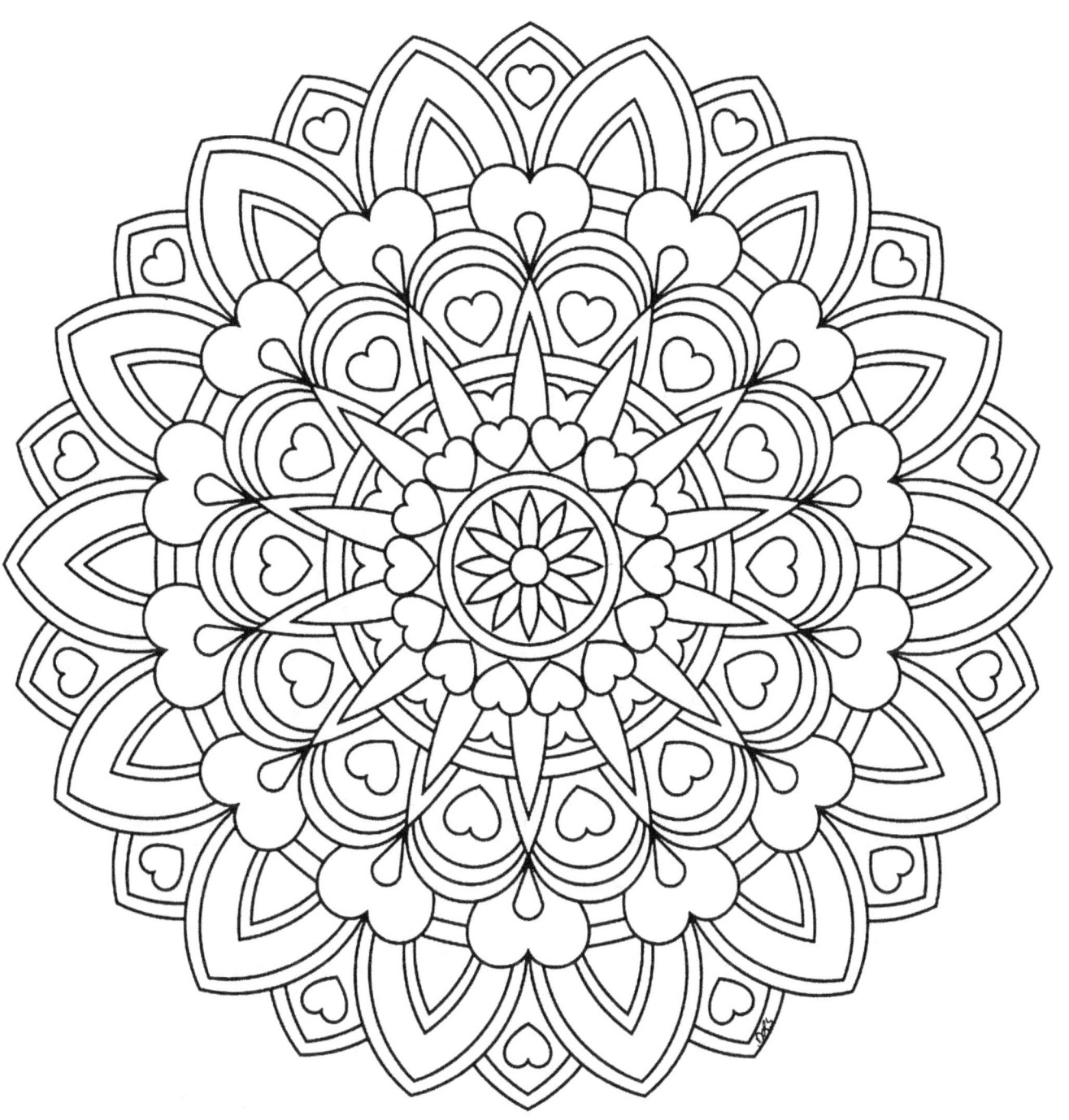

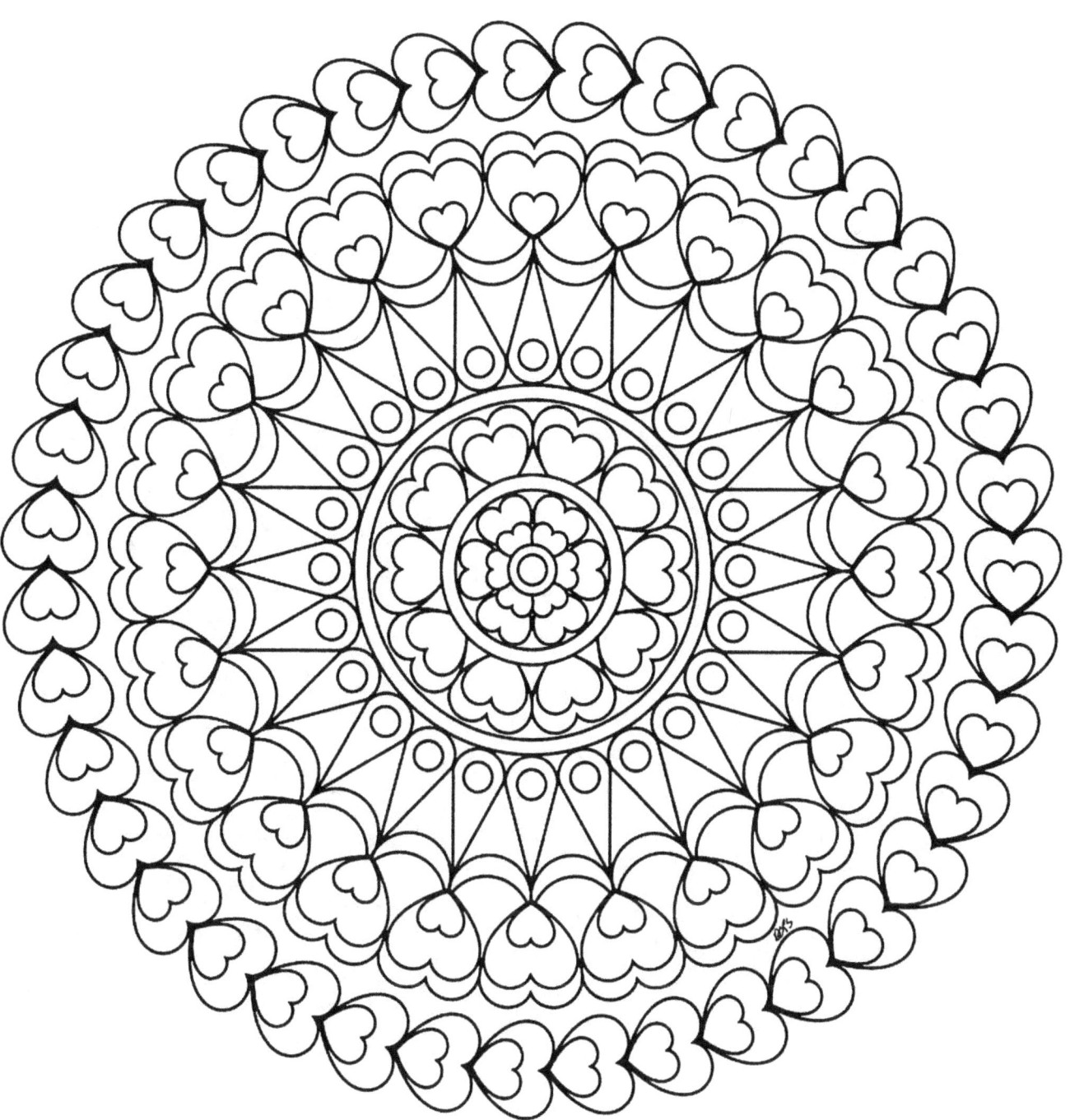

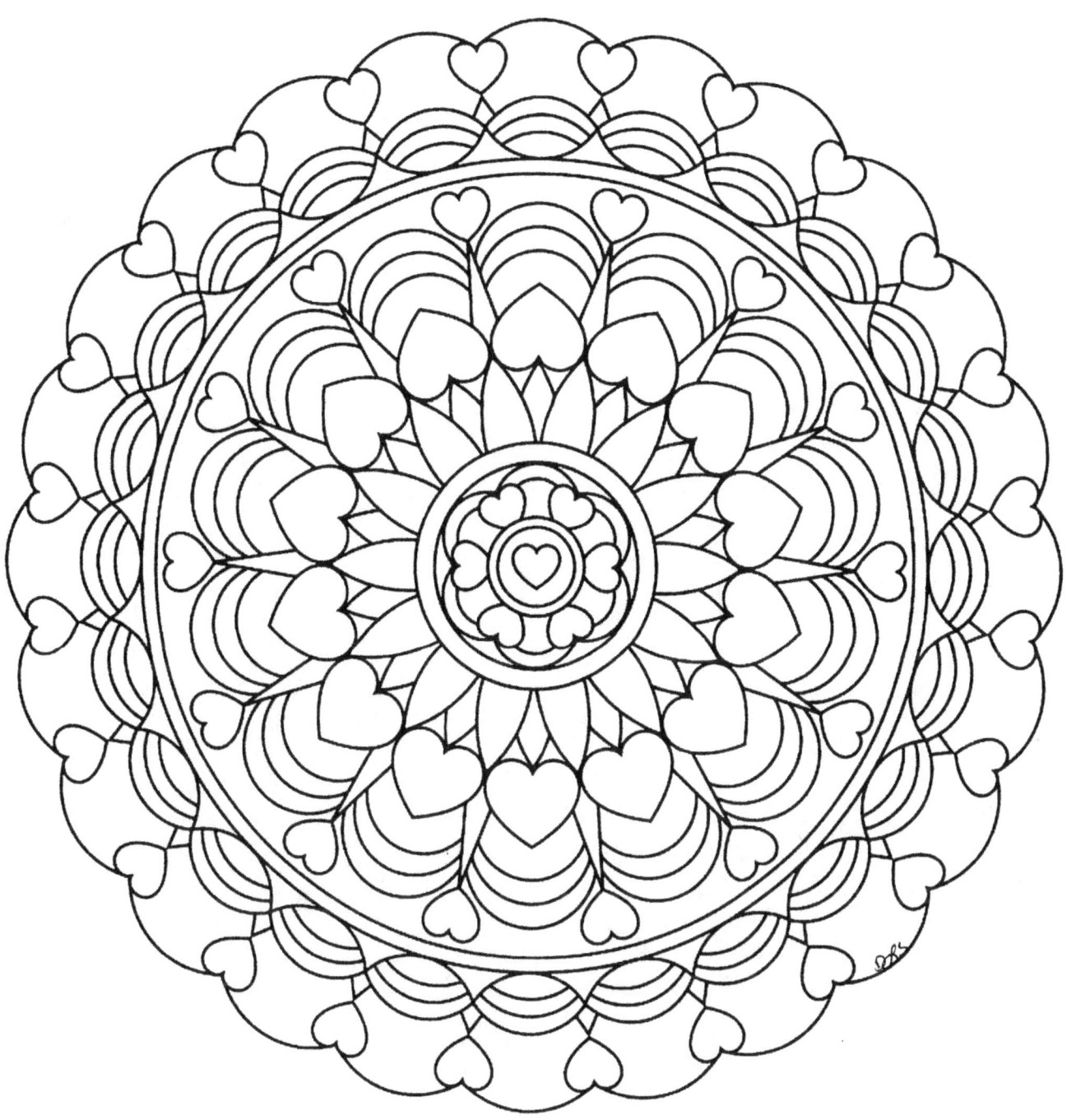

© Copyright 2017 Dwyanna Stoltzfus

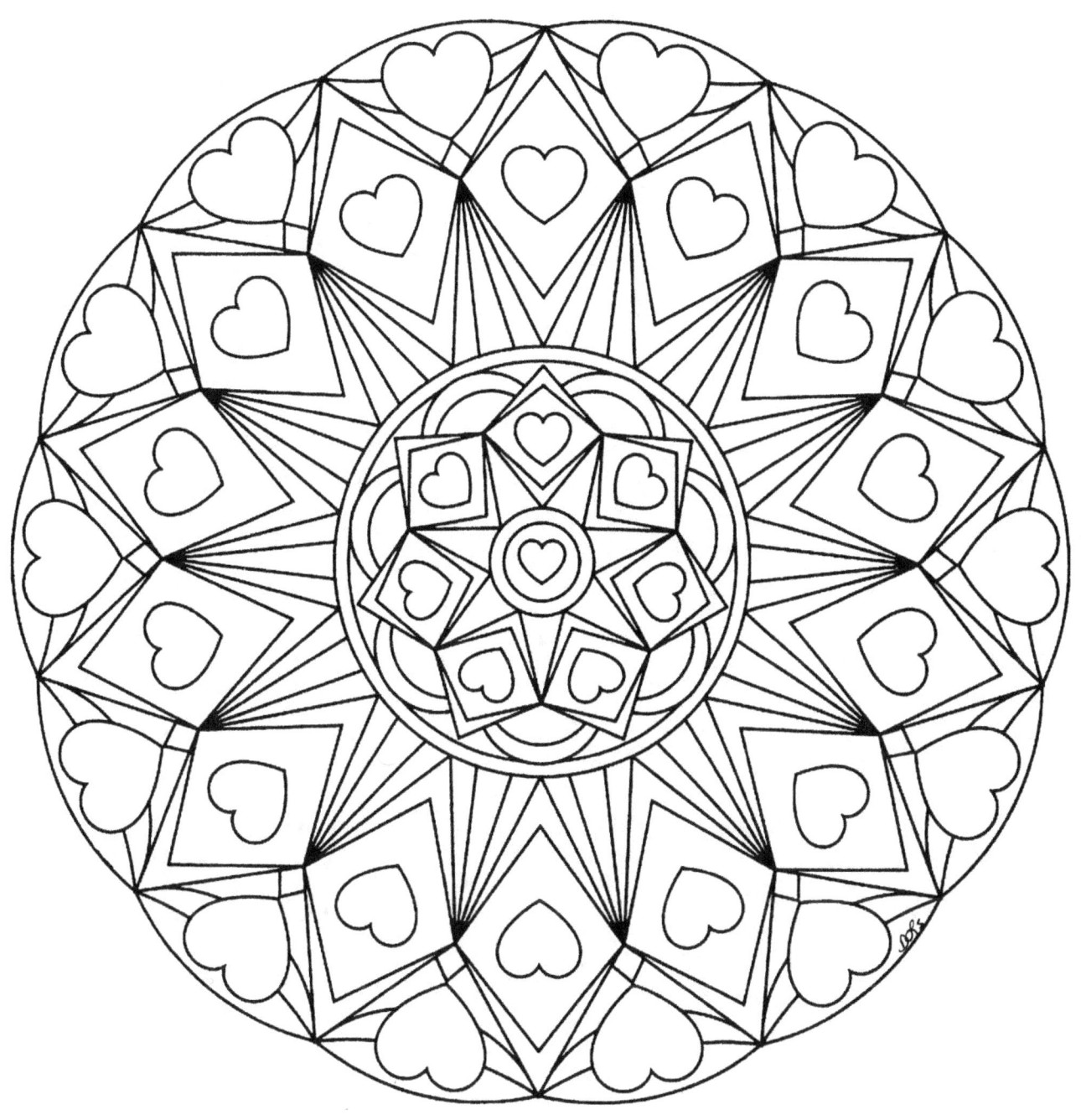

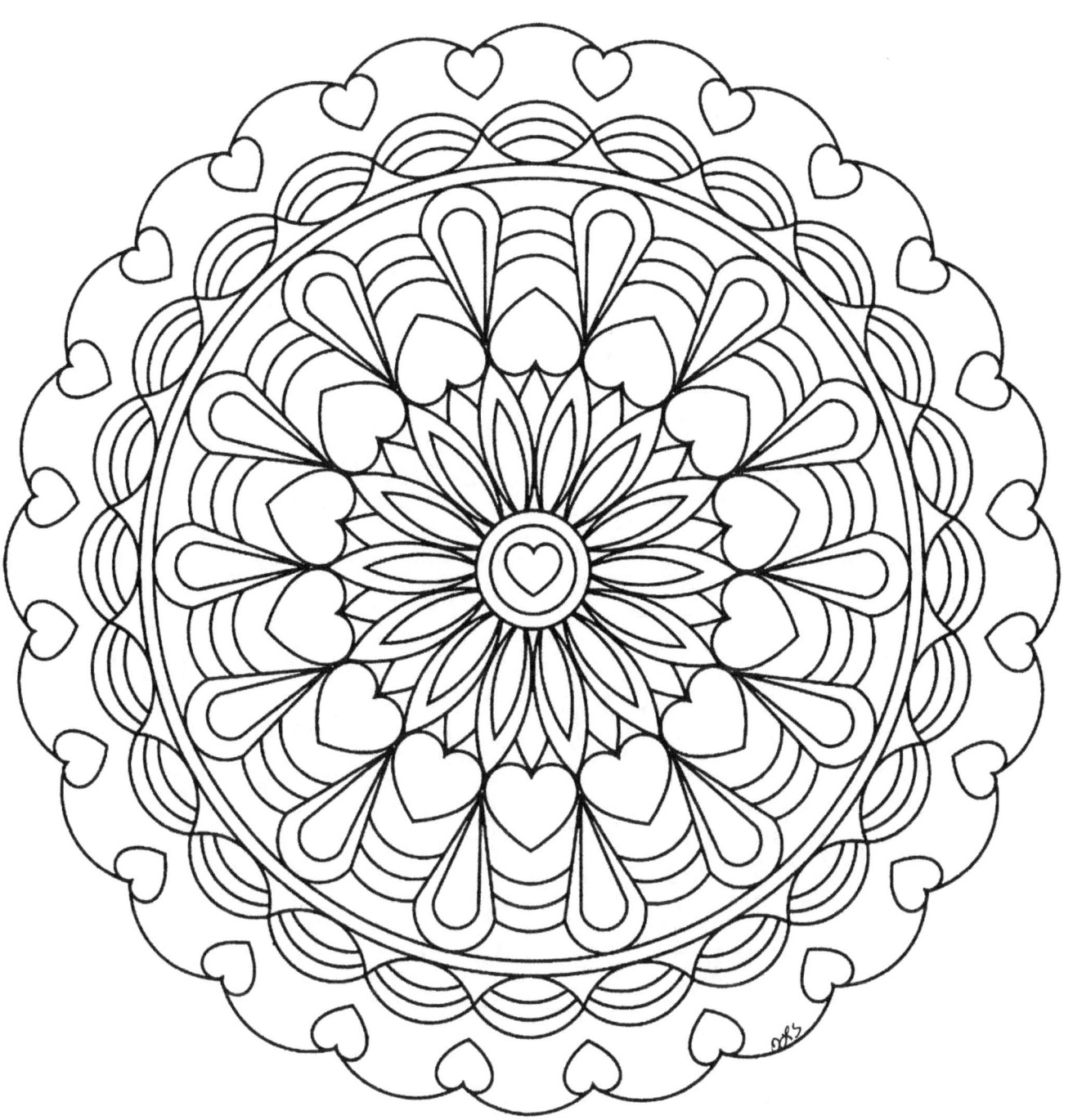

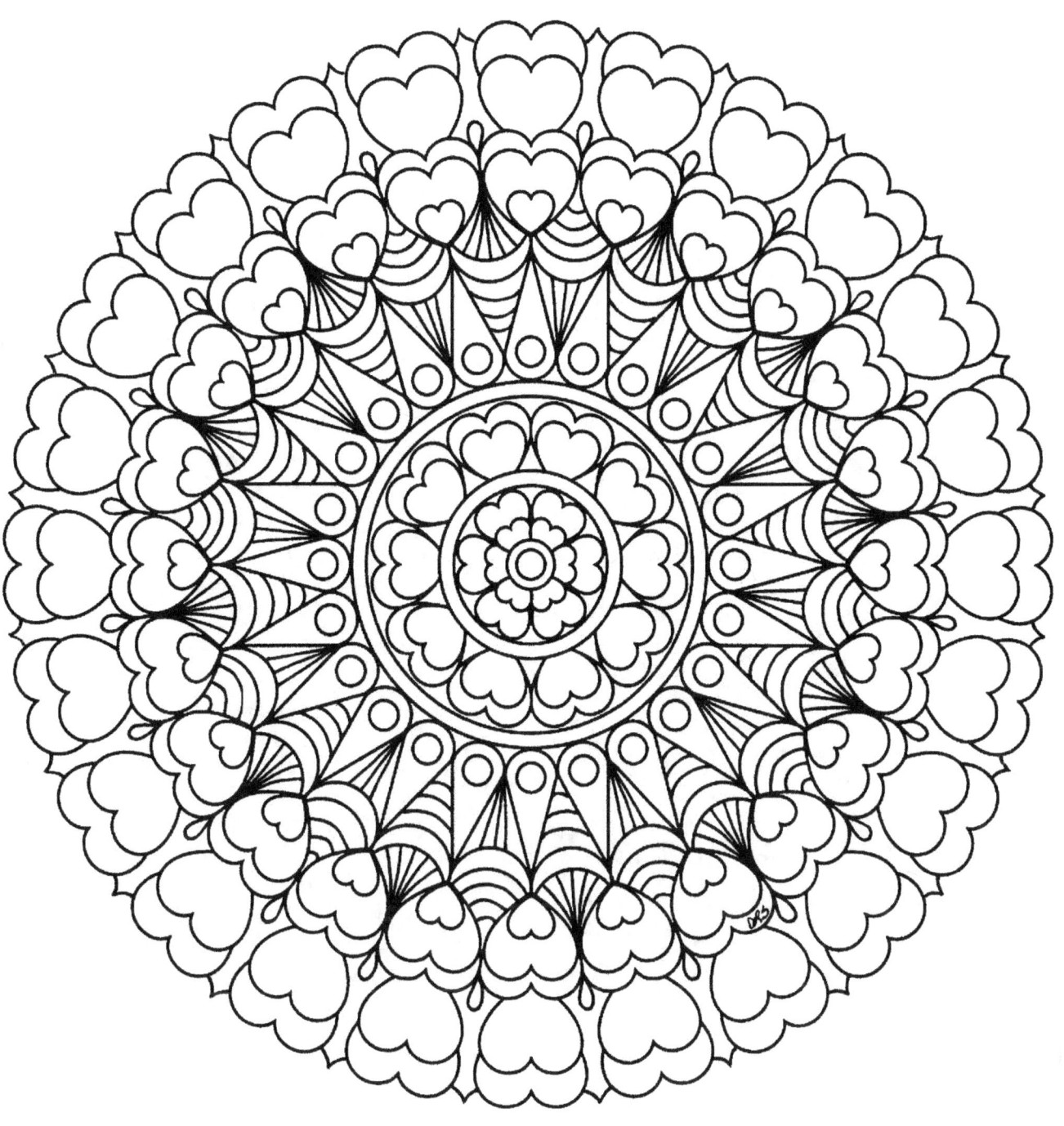

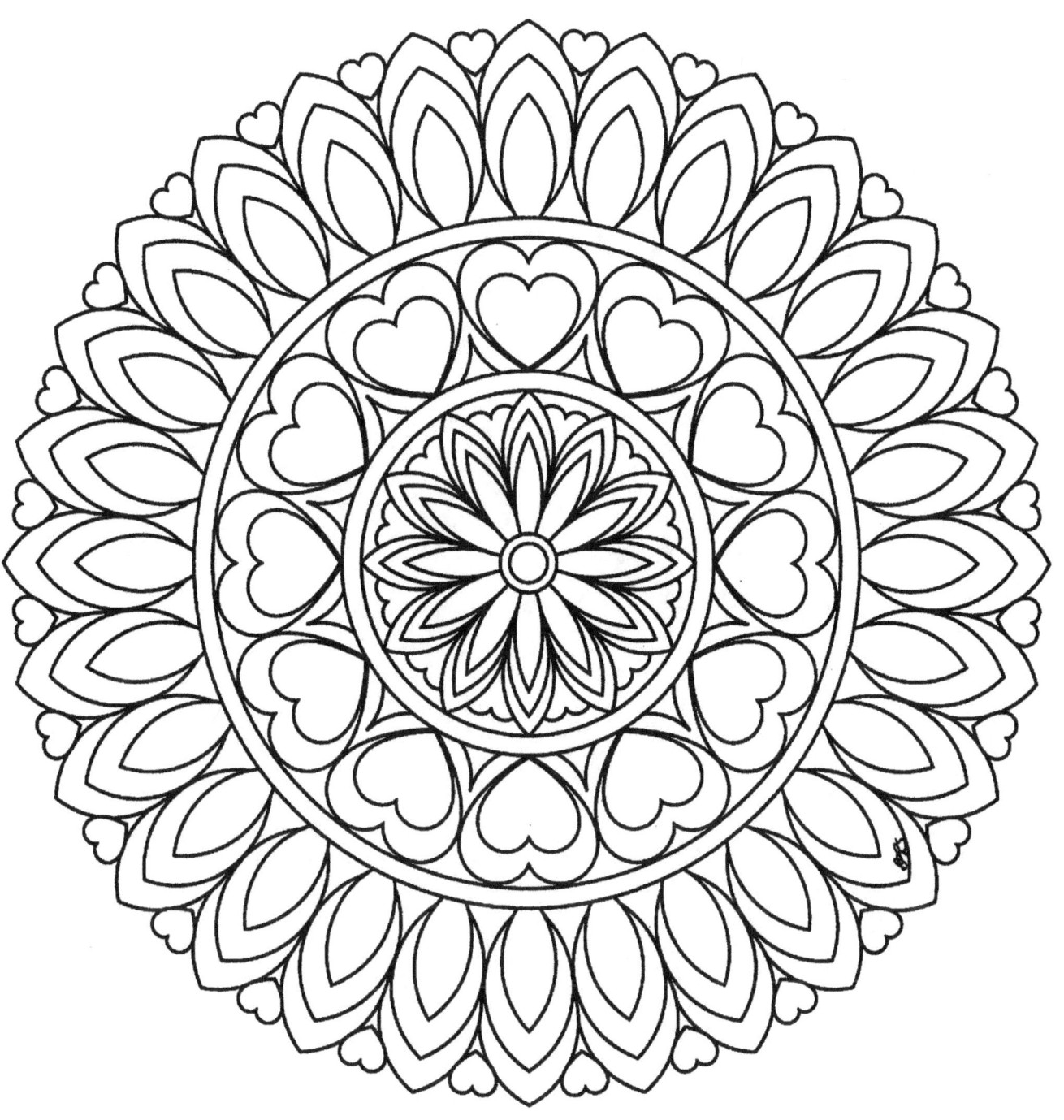

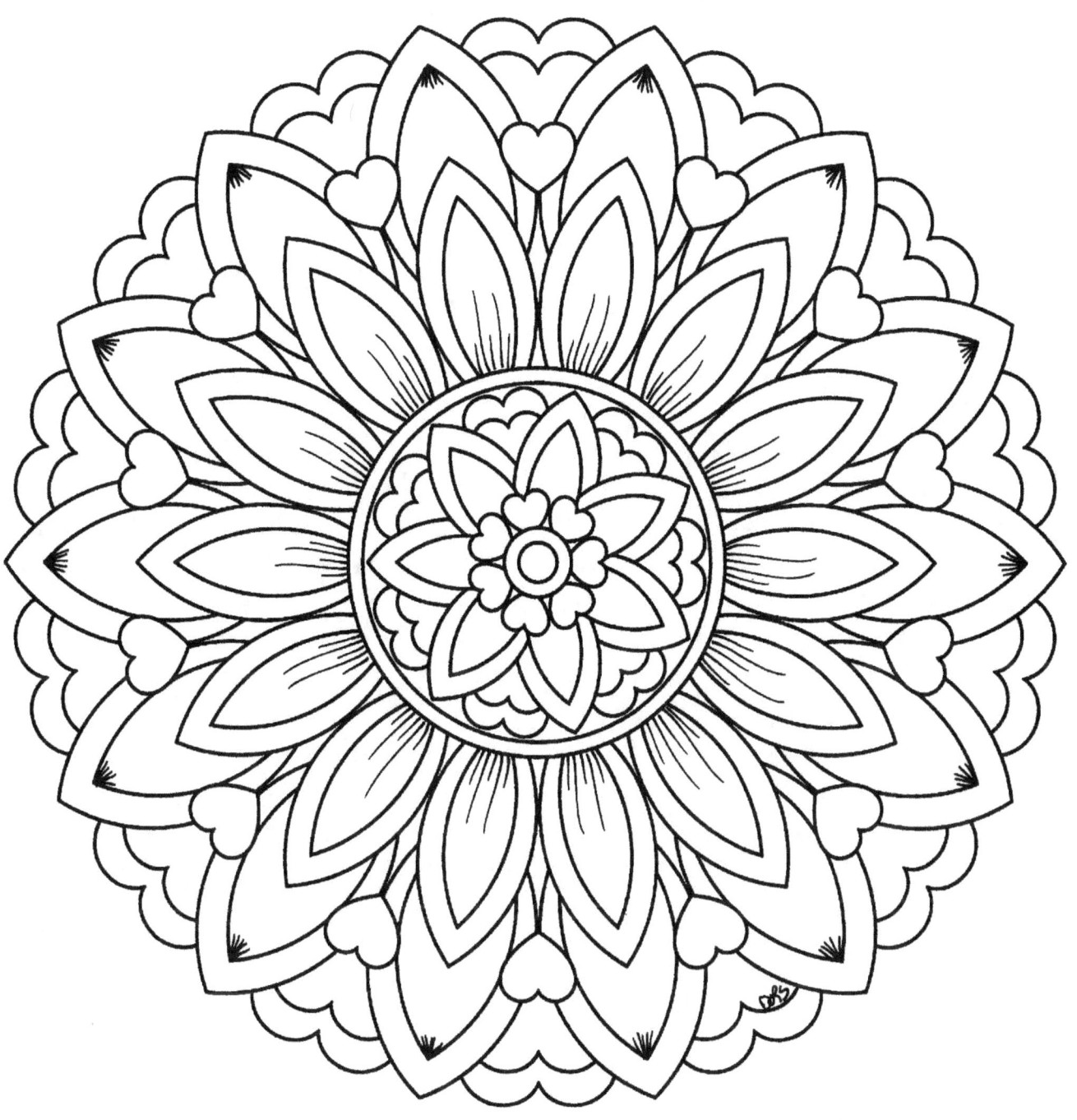

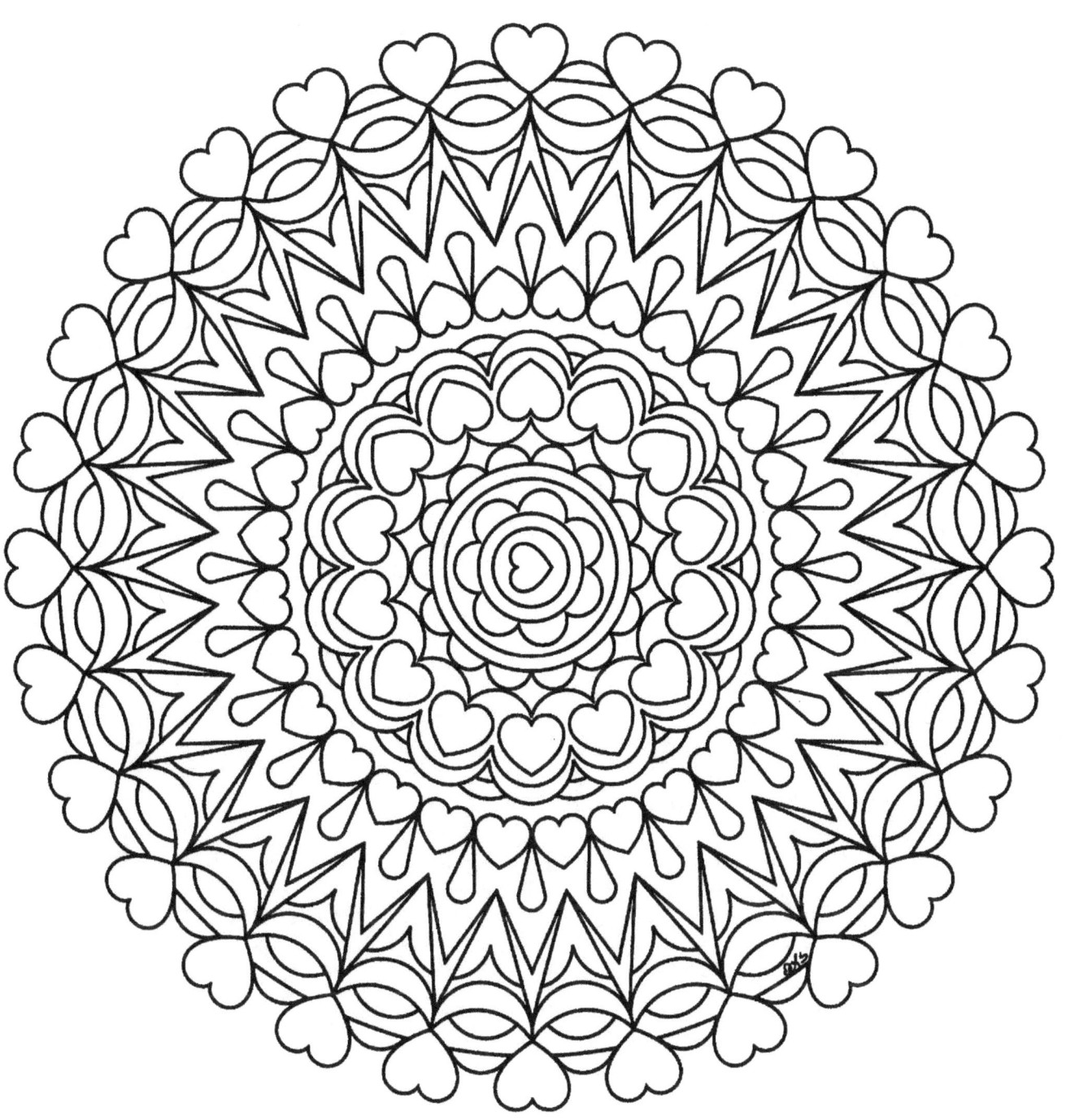

© Copyright 2017 Dwyanna Stoltzfus

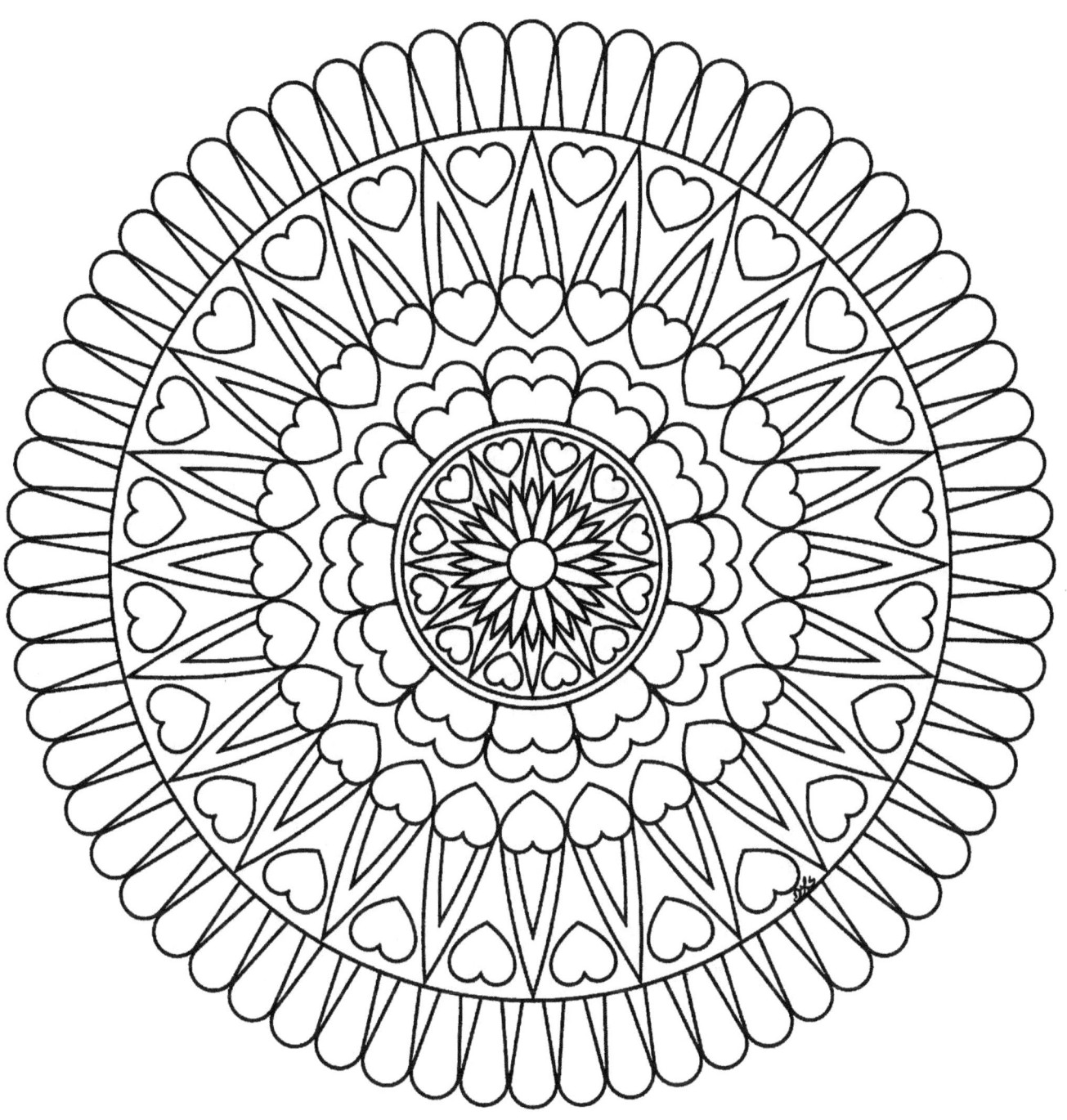

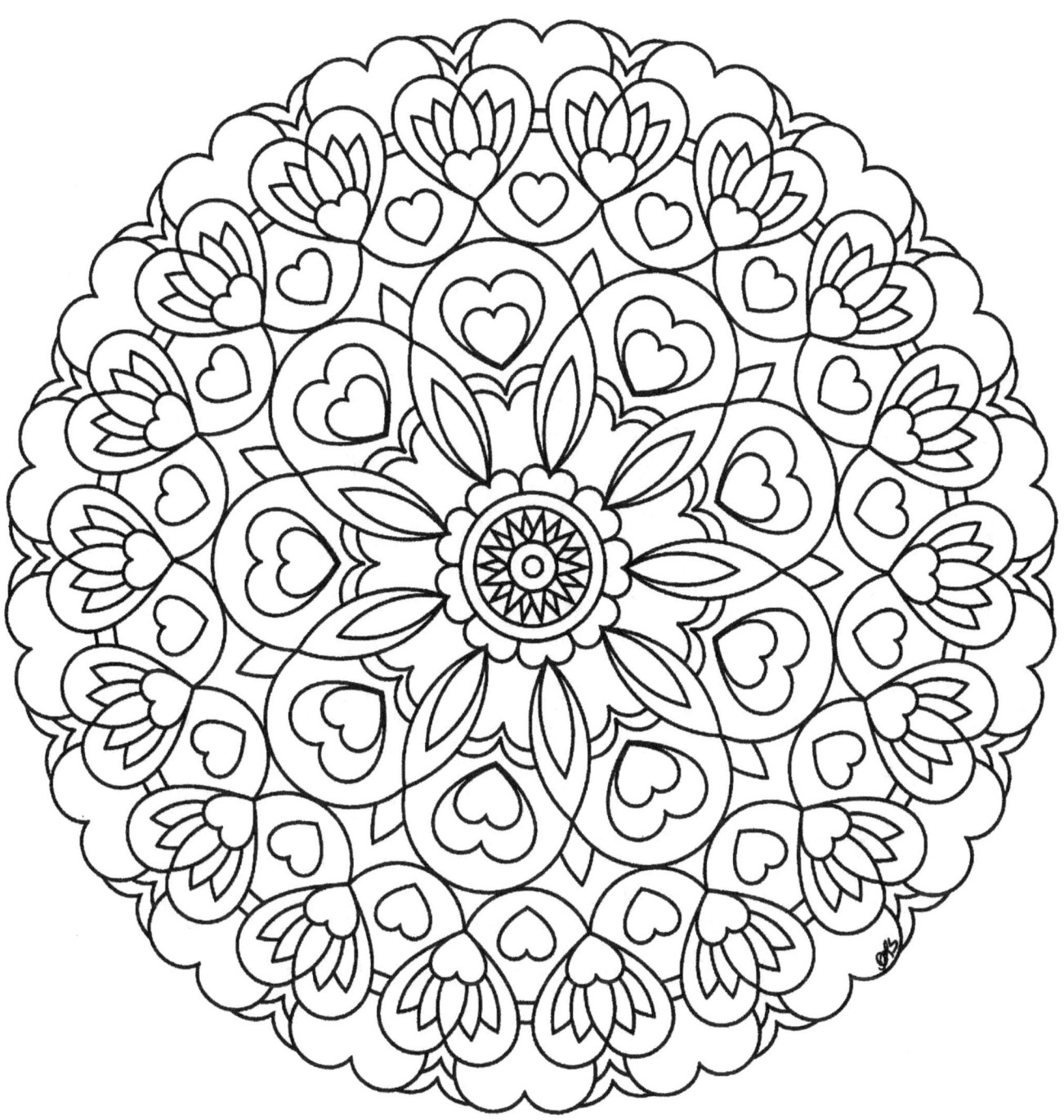

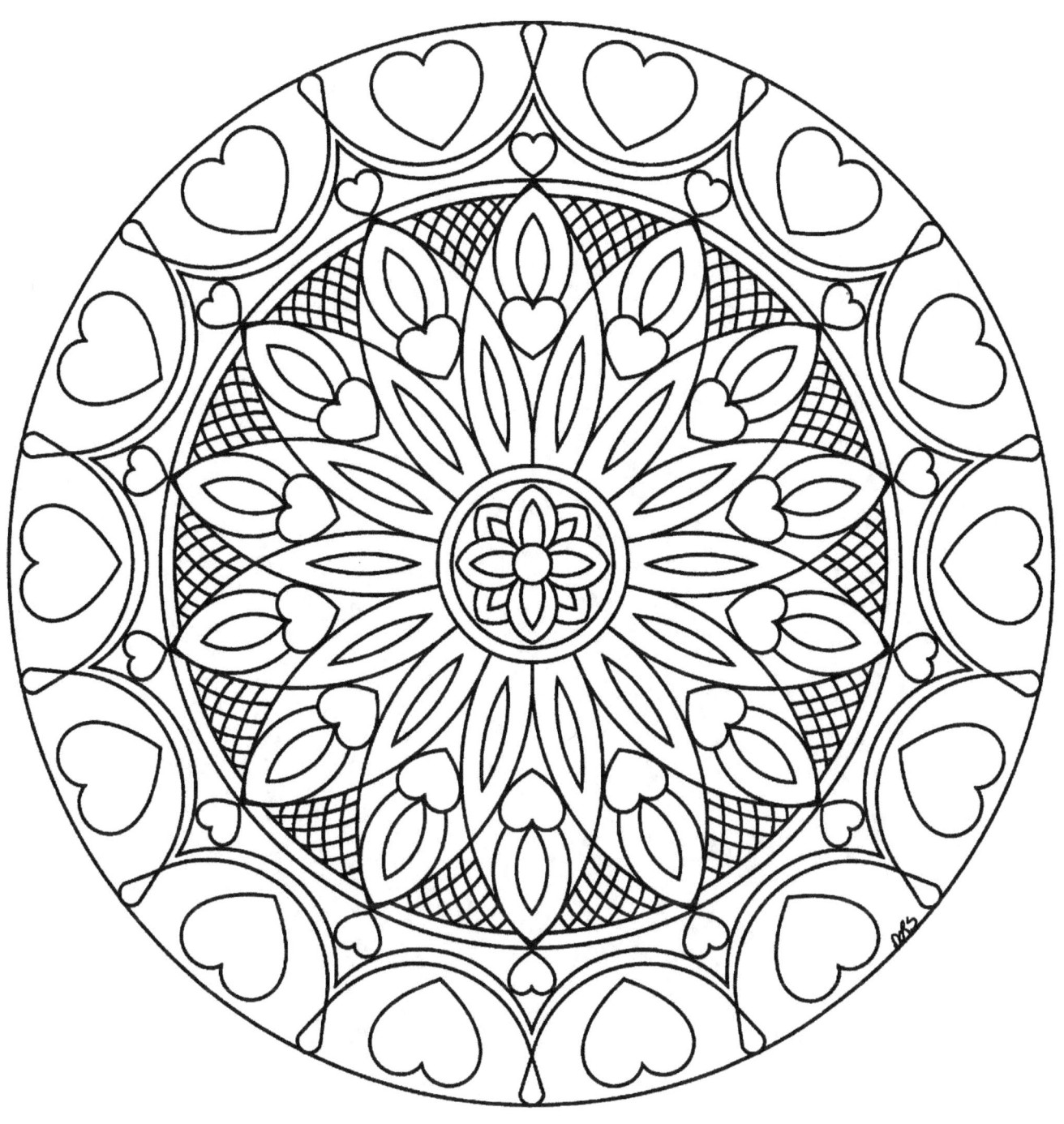

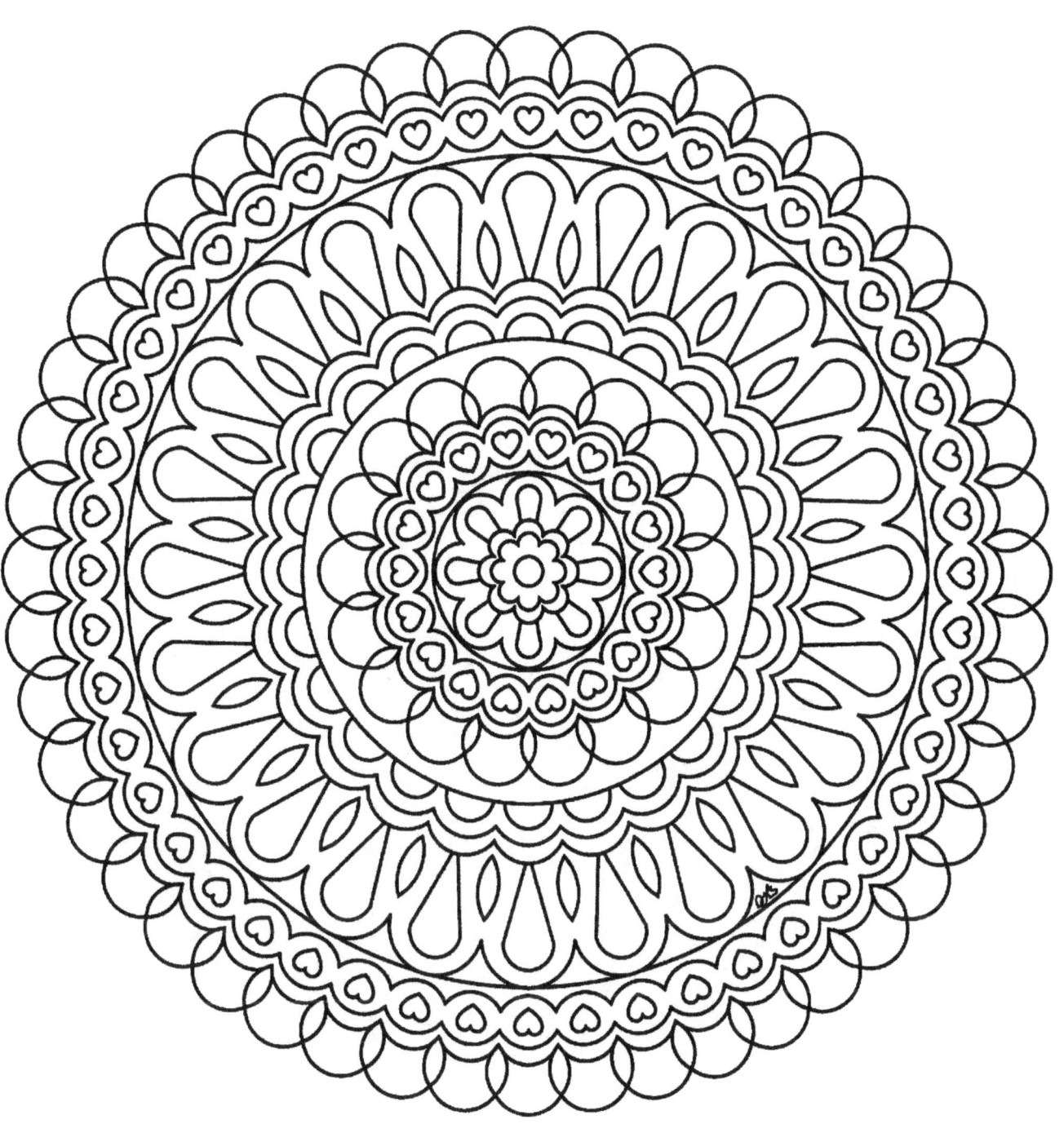

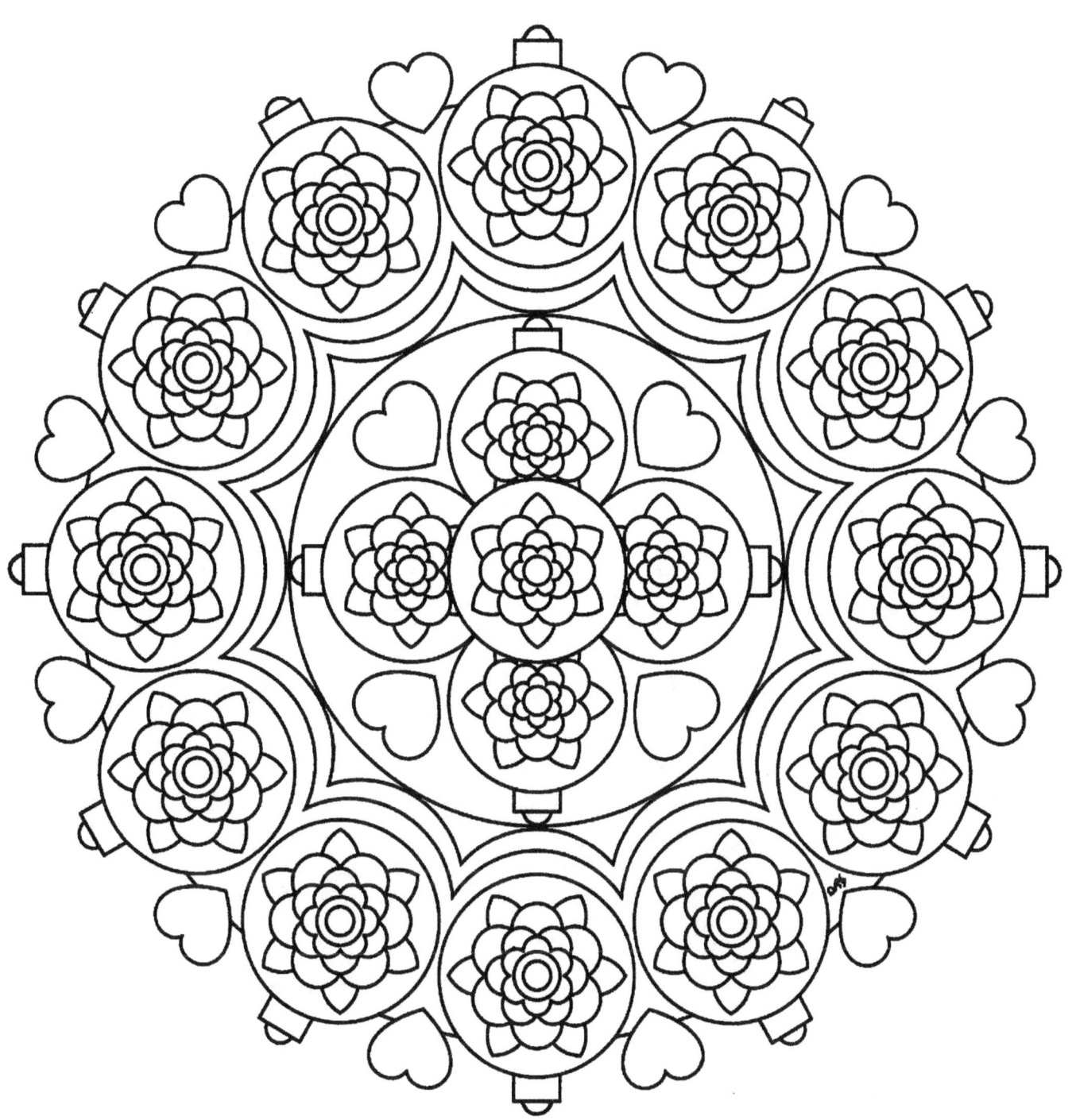

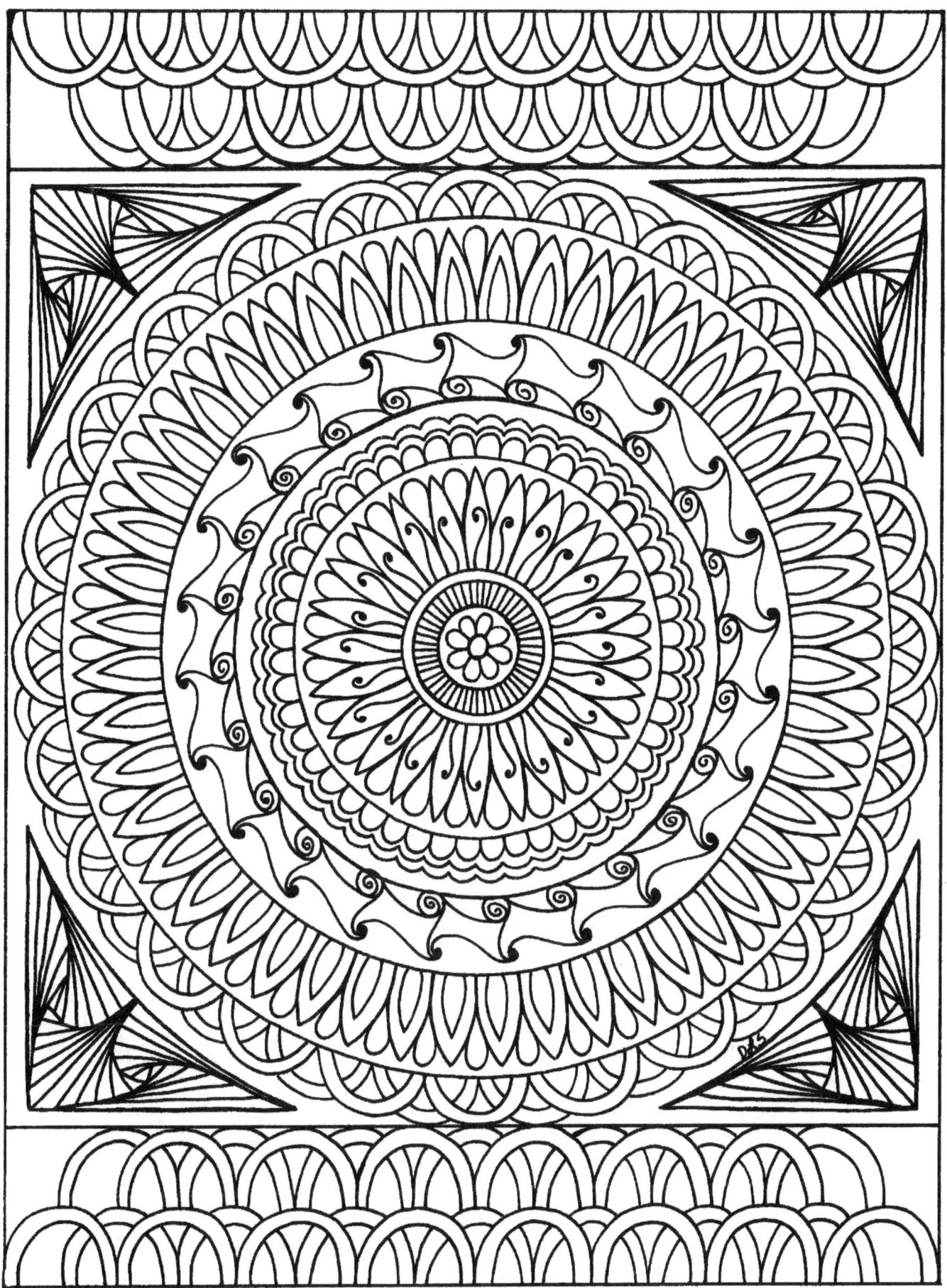

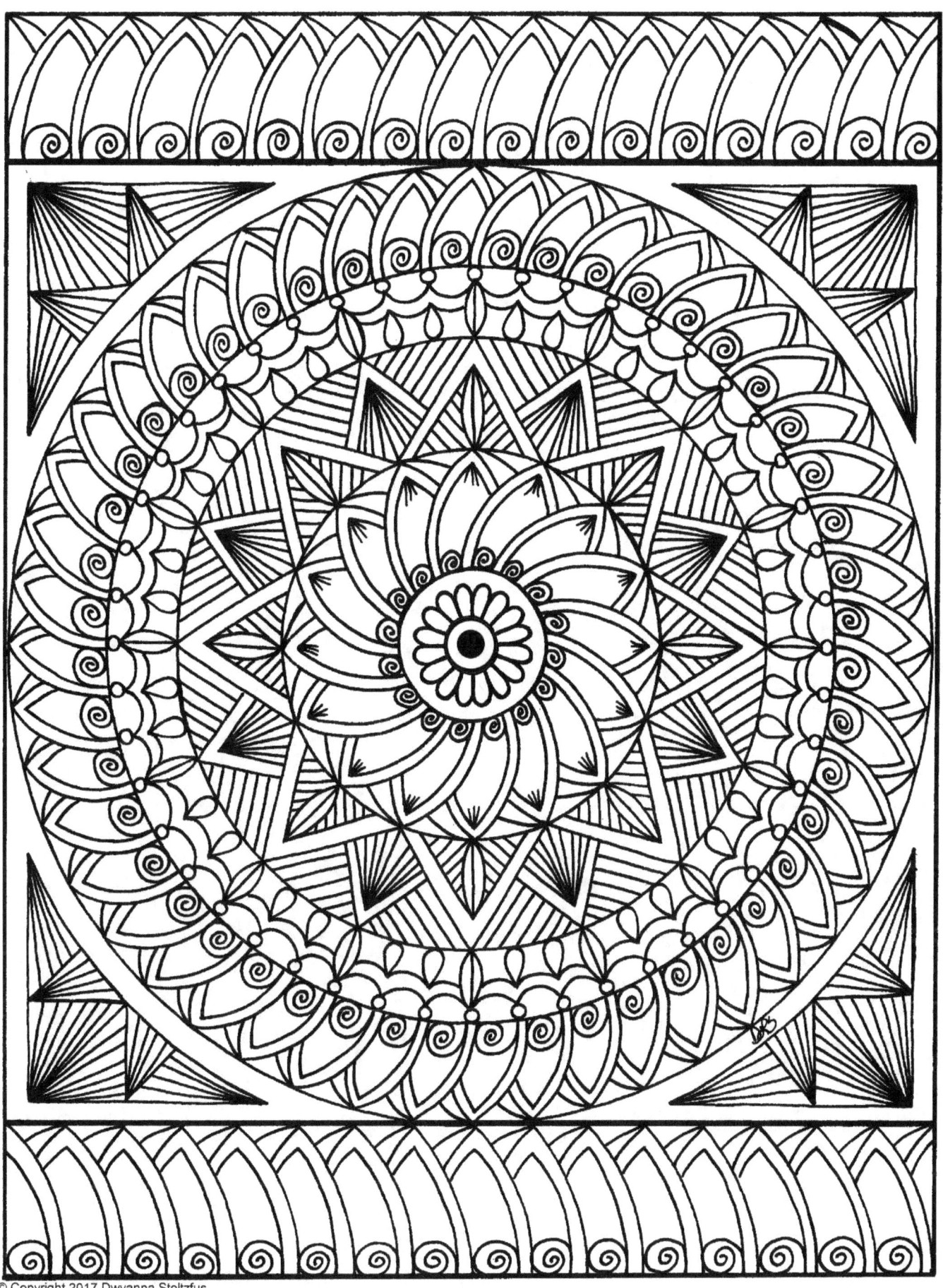

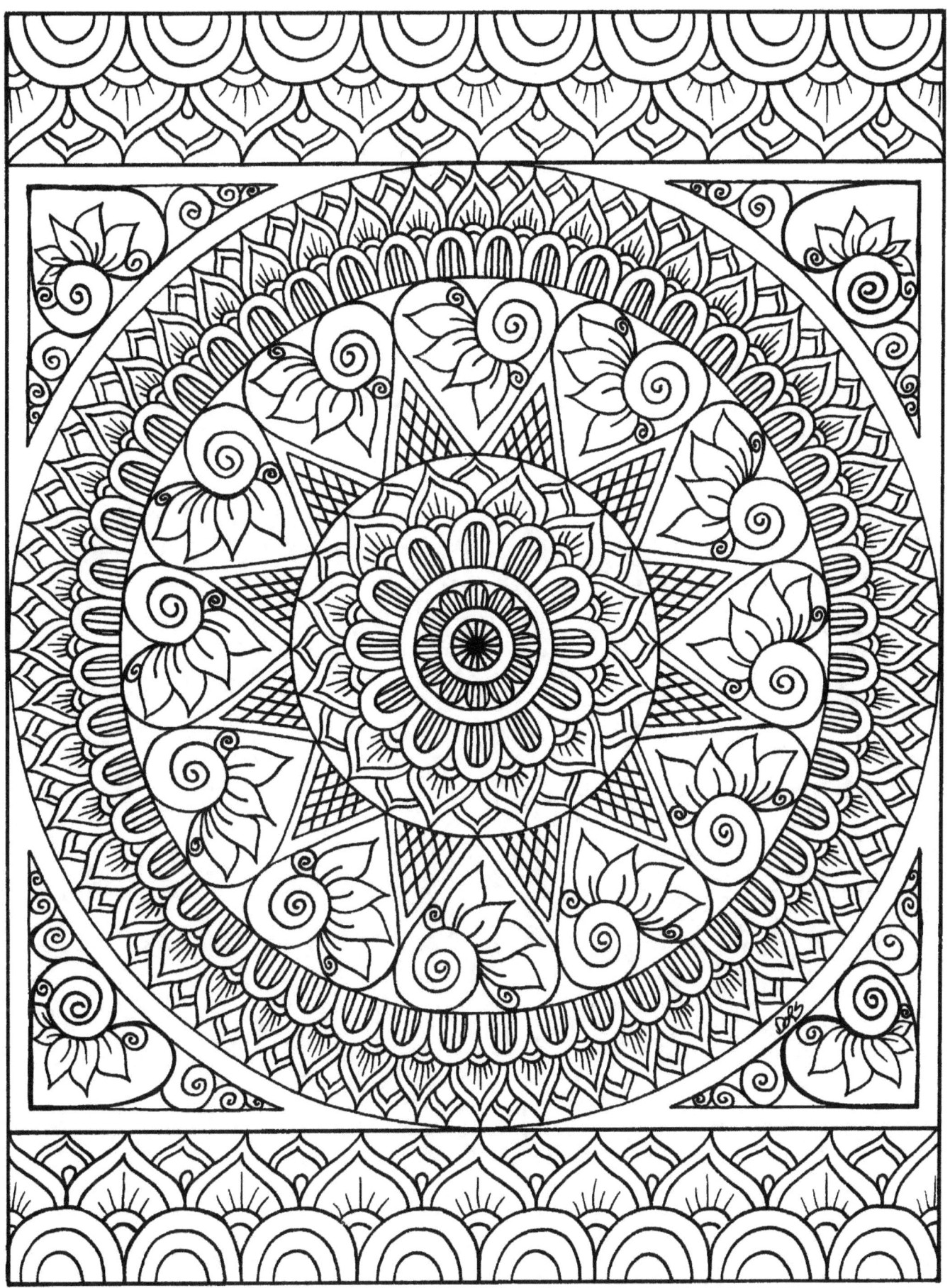

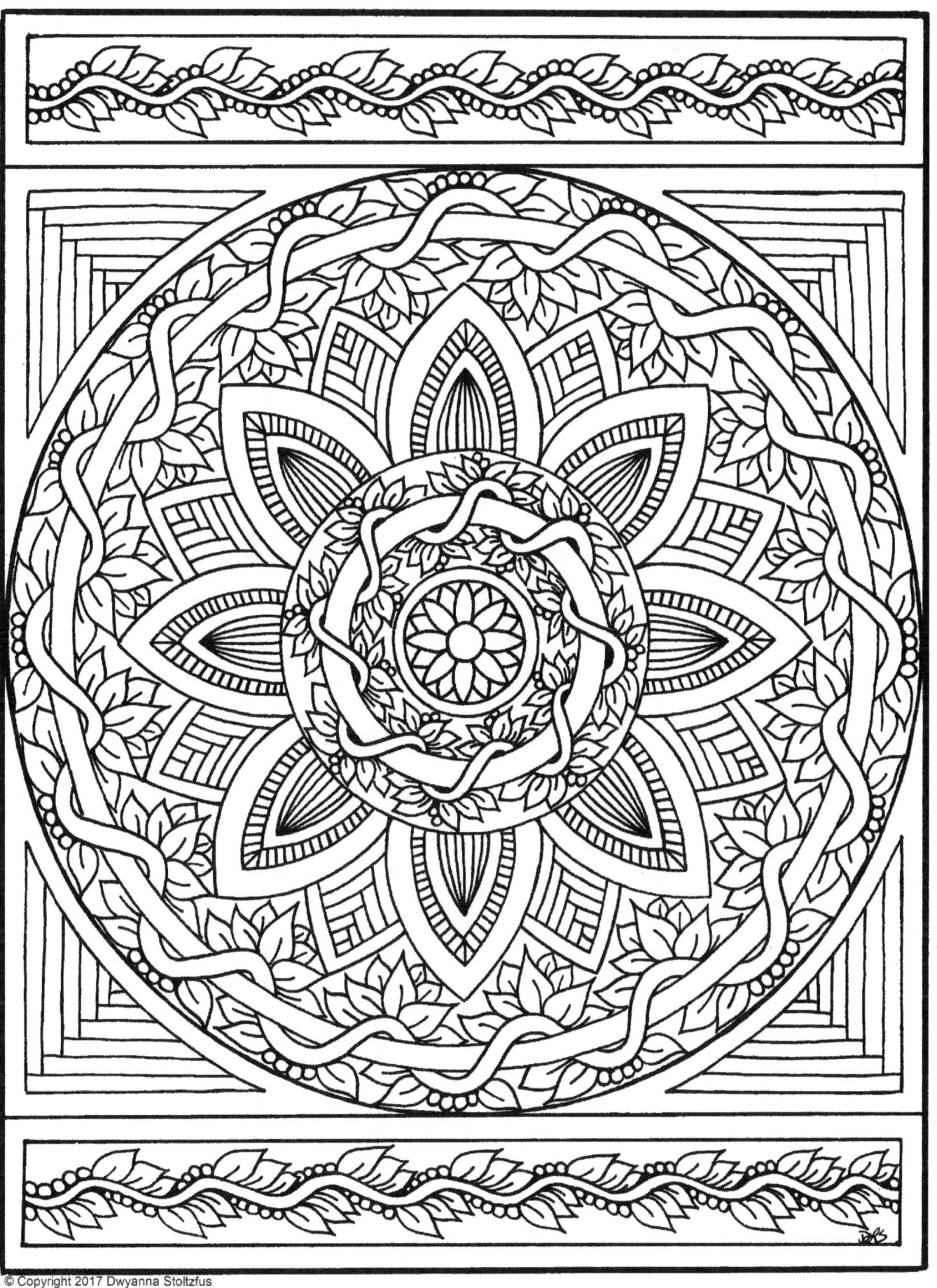

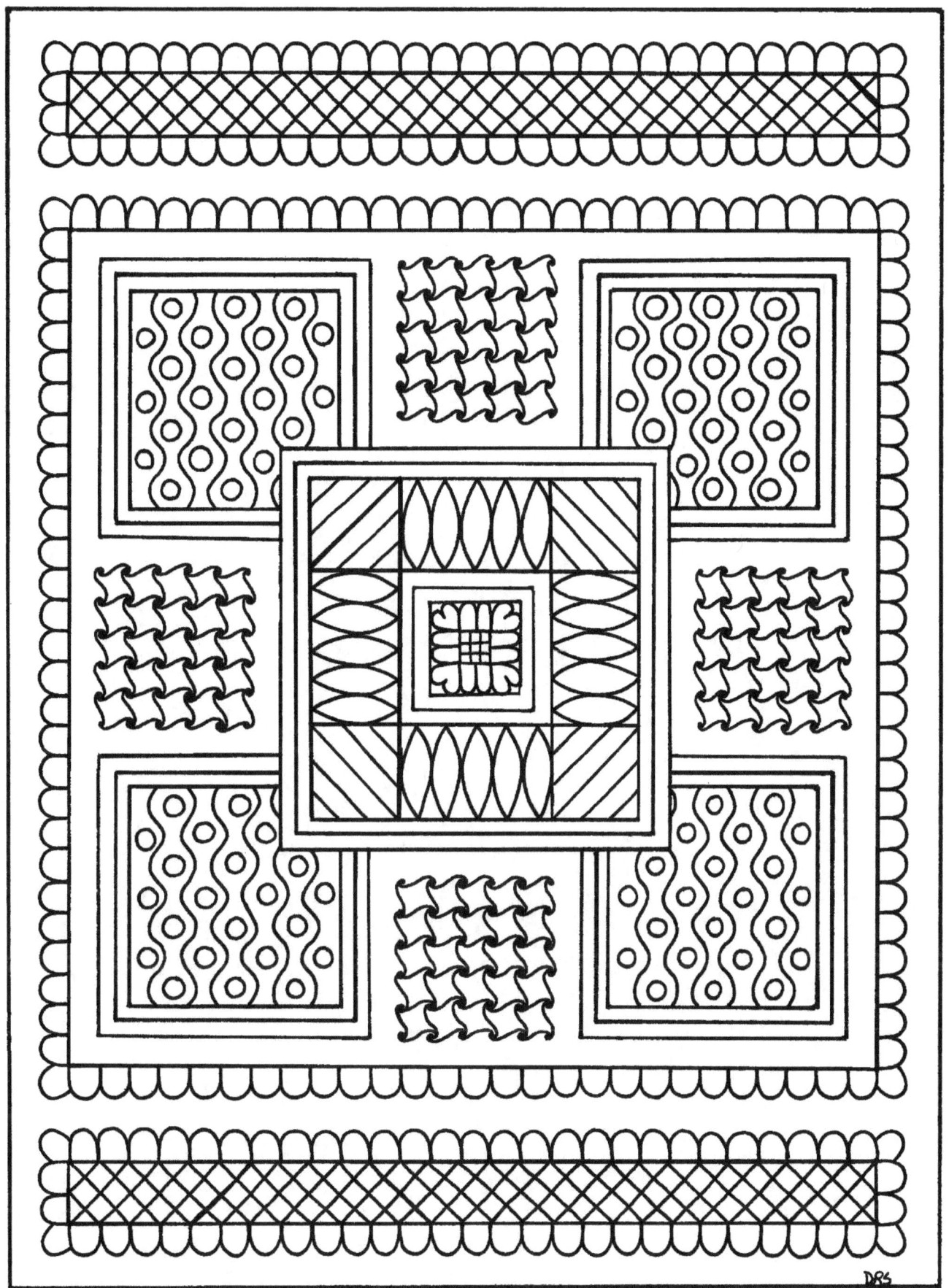

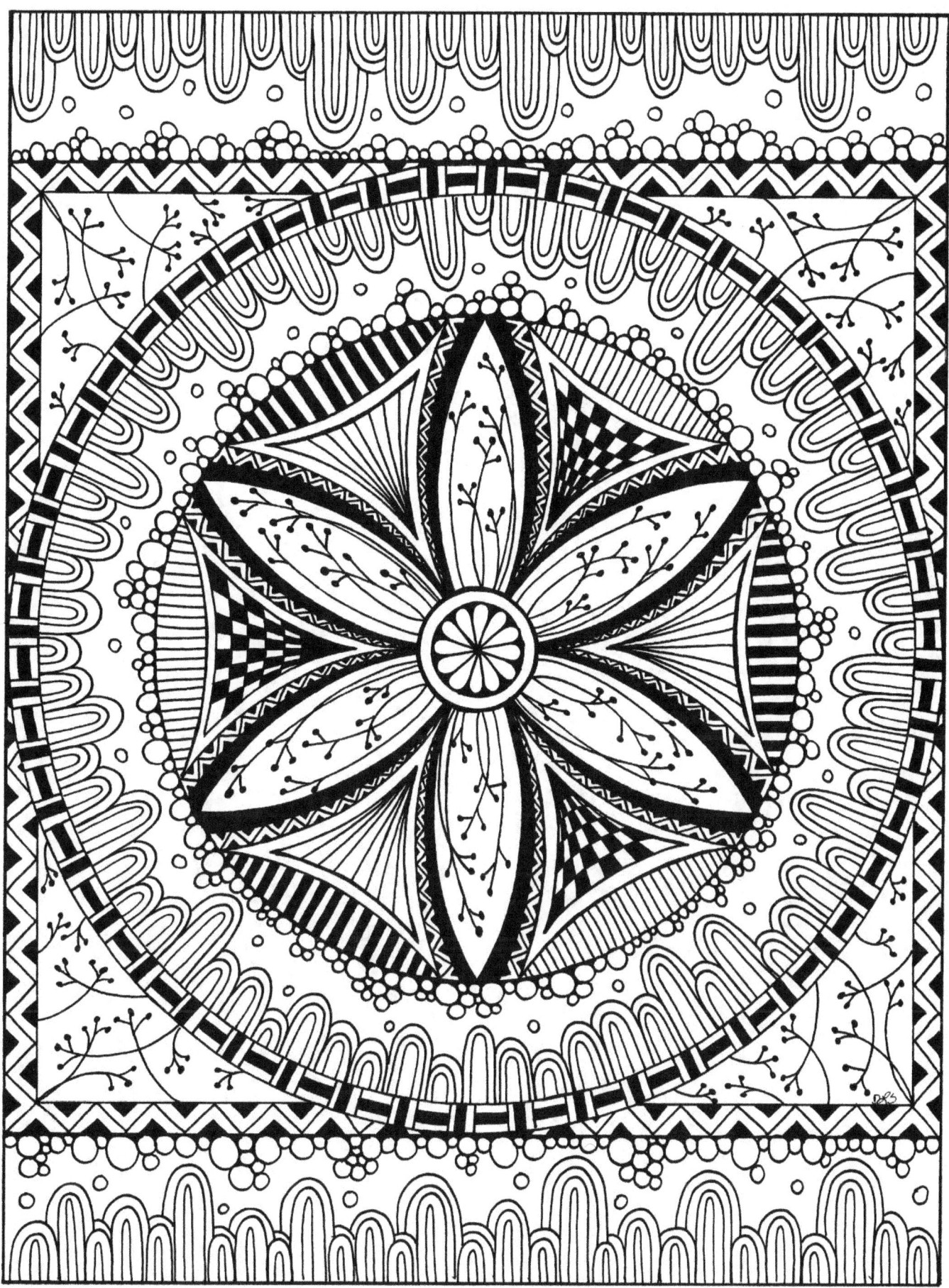

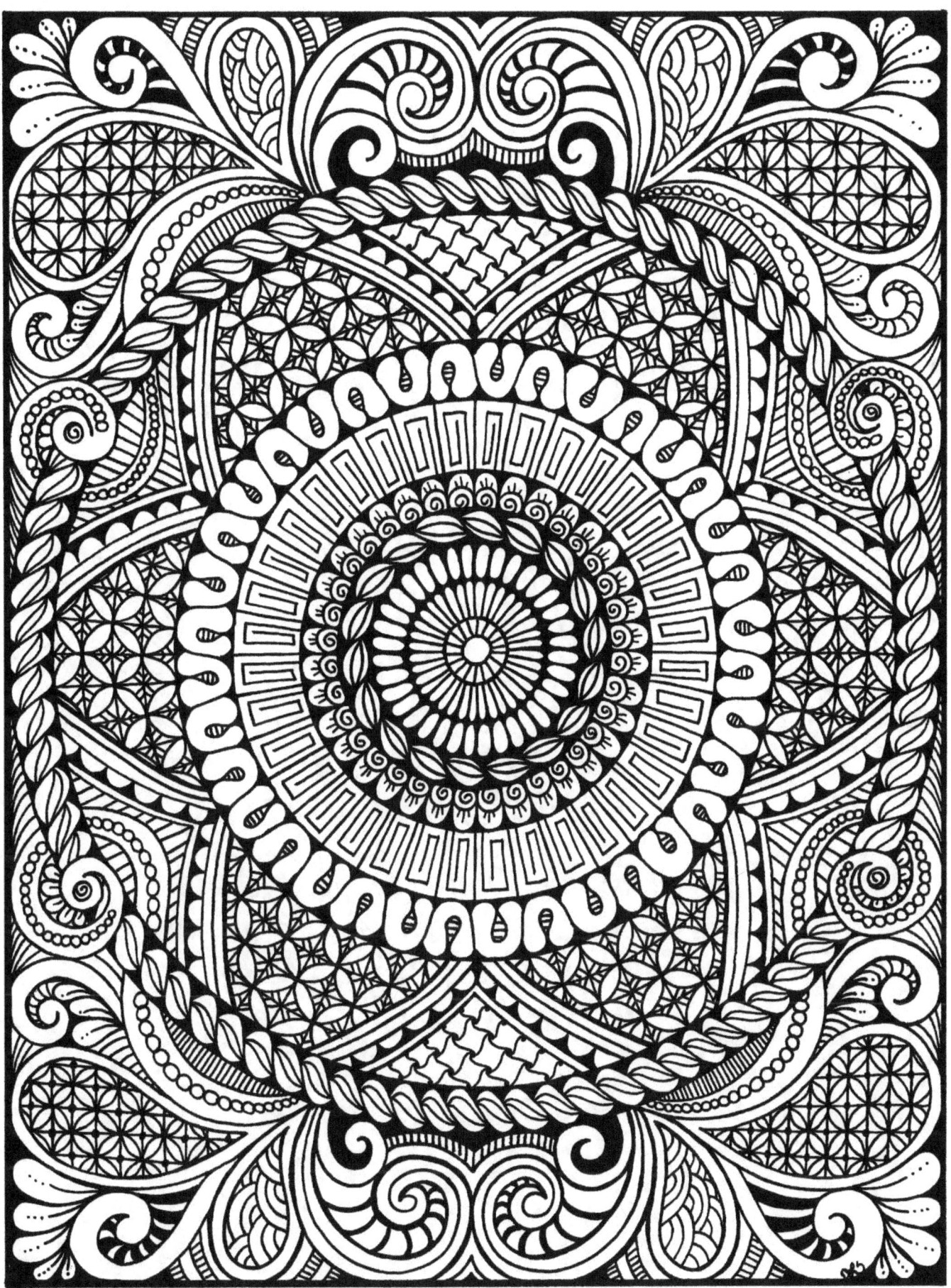

www.ingramcontent.com/pod-product-compliance
Lightning Source LLC
Chambersburg PA
CBHW062356220526
45472CB00008B/1823